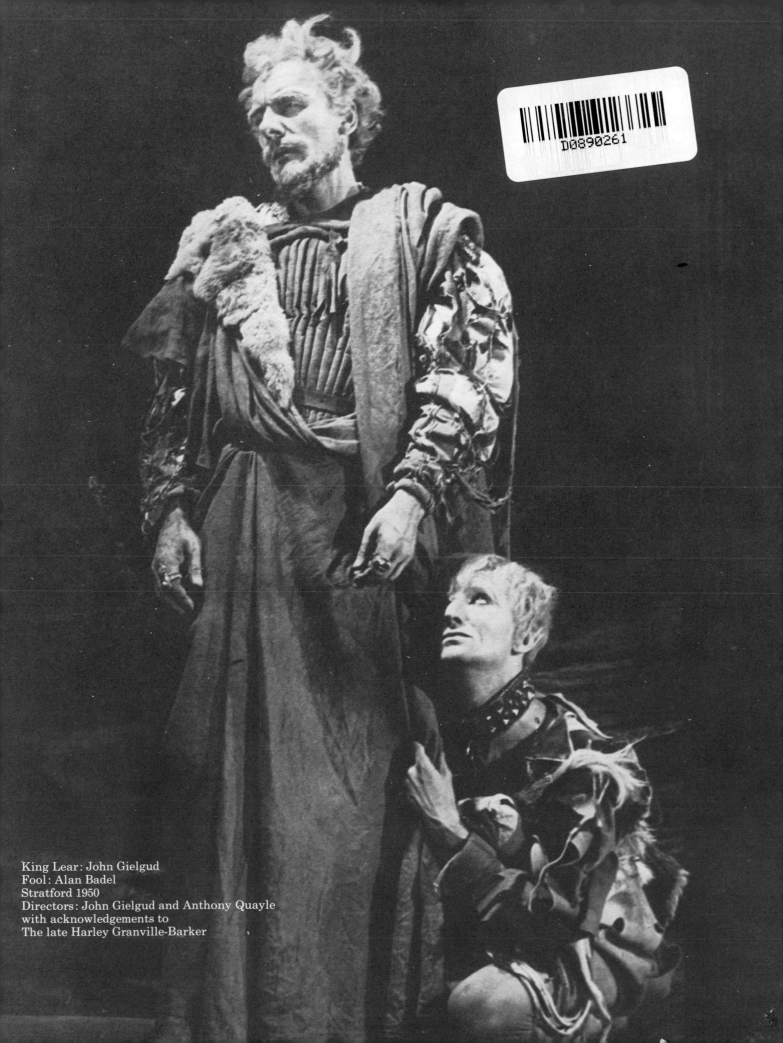

King Lear: John Gielgud
Fool: Alan Badel
Stratford 1950
Directors: John Gielgud and Anthony Quayle
with acknowledgements to
The late Harley Granville-Barker

A Pictorial Companion to
SHAKESPEARE'S PLAYS

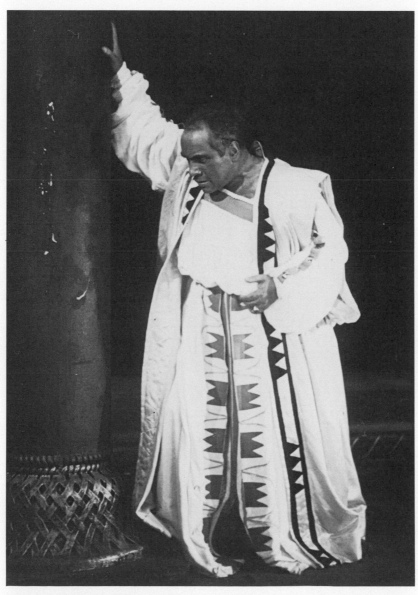

Othello: Frederick Valk
New 1942 (Old Vic Production)
Director: Julius Gellner

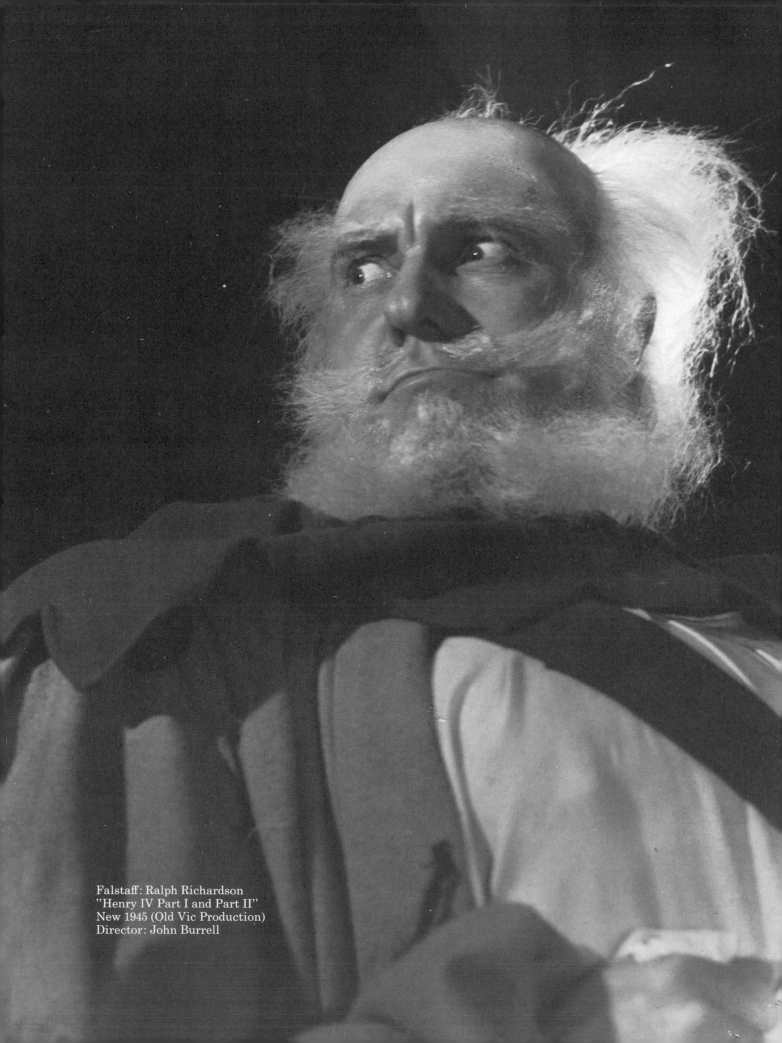

Falstaff: Ralph Richardson
"Henry IV Part I and Part II"
New 1945 (Old Vic Production)
Director: John Burrell

A Pictorial Companion to
SHAKESPEARE'S PLAYS

devised and designed by
Robert Tanitch

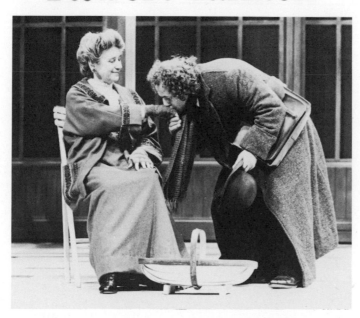

Frederick Muller Limited
London

Title page photograph
"All's Well That Ends Well"
Countess: Peggy Ashcroft
Lavache: Geoffrey Hutchings
RSC Stratford 1981
Director: Trevor Nunn

The book is dedicated to my friends and The National Hospital, Queen Square, London, WC1.

British Library Cataloguing
in Publication Data

Tanitch, Robert
 A pictorial companion to
 Shakespeare's plays.
 1. Shakespeare, William
 —Stage history—
 Pictorial works
 I. Title
 792.9′5 PR3091

 ISBN 0-584-11027-8

First published in 1982
by Frederick Muller Limited
Dataday House, Alexandra Road,
Wimbledon, London SW19 7JU

Copyright © Robert Tanitch 1982

Robert Tanitch's designs have been realised by Heather Sherratt.

Filmset in 'Monophoto' Century Schoolbook and printed by BAS Printers Limited, Over Wallop, Hampshire

NOTES

THEATRES:	All theatres listed in this book are in London unless otherwise stated.
RSC:	The Royal Shakespeare Company performs at The Royal Shakespeare Theatre and The Other Place in Stratford-upon-Avon and at The Barbican Centre in London. Between 1960–1982 The RSC's London home was The Aldwych Theatre and between 1960–1982, they also performed at The Warehouse. The theatre and the date in the captions refer to the particular photograph used. It can be assumed that all London productions have been seen at Stratford; but not vice versa.
STRATFORD:	The Royal Shakespeare Company did not come into existence until 1960. So all photographs captioned just "Stratford" are of productions at The Memorial Theatre, Stratford-upon-Avon prior to that date.
OLD VIC:	The Old Vic Theatre was bombed in 1940 and did not re-open until 1950. During some of that period The Old Vic Company performed at The New Theatre, London.
NATIONAL:	All National Theatre productions were at The Old Vic Theatre from 1963 to 1974. The company then moved into their present home on the South Bank.
DIRECTORS:	Directors, as we understand the role today, have been termed "stage managers" and "producers" in the past; but to avoid confusion (since the earlier terms now have different meanings in the theatre) all productions, past and present, are described as having a director.

Contents

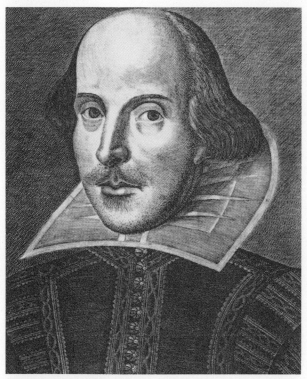

William Shakespeare 1564–1616

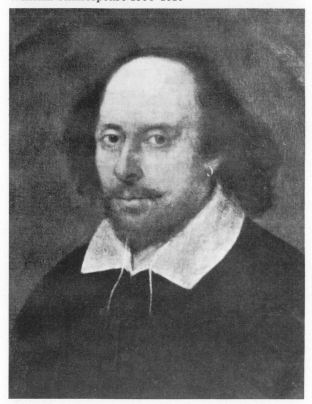

The Comedy of Errors

1
Dromio of Syracuse: Michael Williams
Dromio of Ephesus: Nickolas Grace
RSC Aldwych 1977
Director: Trevor Nunn

2
The Theodore Komisarjevsky 1938
Stratford Production

Henry VI

3
Henry VI: Alan Howard
RSC Stratford 1977
Director: Terry Hands

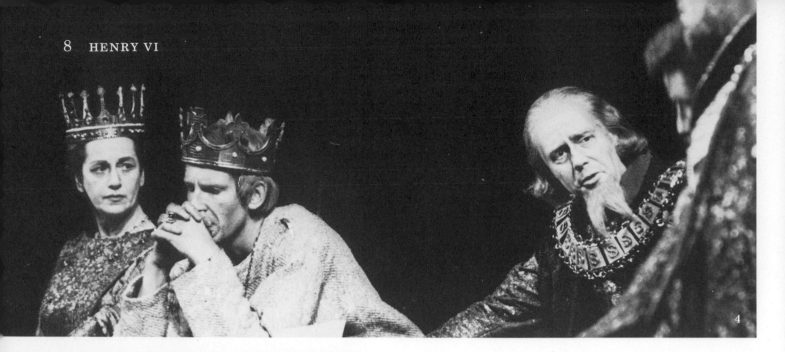

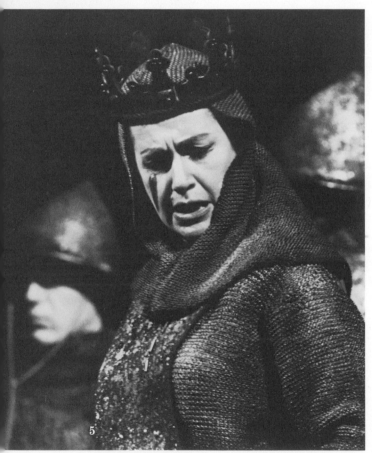

4 5
Margaret: Peggy Ashcroft
Henry VI: David Warner
Humphrey: John Welsh
"The War of the Roses"
RSC Stratford 1963
Director: Peter Hall
with John Barton and
Frank Evans

RICHARD:

Why Love forswore me in my Mother's womb:
And for I should not deal in her soft laws,
She did corrupt frail Nature with some bribe,
To shrink mine arm up like a wither'd shrub,
To make an envious mountain on my back,
Where sits Deformity to mock my body;
To shape my legs of an unequal size,
To disproportion me in every part:
Like to a chaos, or an unlick'd bear-whelp,
That carries no impression like the dam.
And am I then a man to be belov'd?
Oh monstrous fault, to harbour such a thought.
Then since this Earth affords no joy to me,
But to command, to check, to o'erbear such,
As are of better person than myself:
I'll make my Heaven, to dream upon the Crown,
And while I live, t' account this World but Hell,
Until my mis-shap'd trunk, that bears this head,
Be round impaled with a glorious Crown.
And yet I know not how to get the Crown,
For many lives stand between me and home:
And I, like one lost in a thorny wood,
That rents the thorns, and is rent with the thorns,
Seeking a way, and straying from the way,
Not knowing how to find the open air,
But toiling desperately to find it out,
Torment myself, to catch the English Crown:
And from that torment I will free myself,
Or hew my way out with a bloody axe.

PART III ACT III SCENE II

Richard III

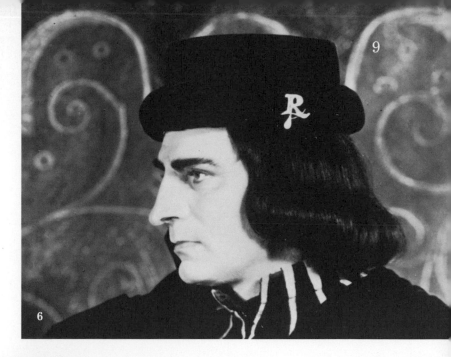

6 7
Richard III: Laurence Olivier
Lady Anne: Claire Bloom
London Films 1955
Director: Laurence Olivier

6

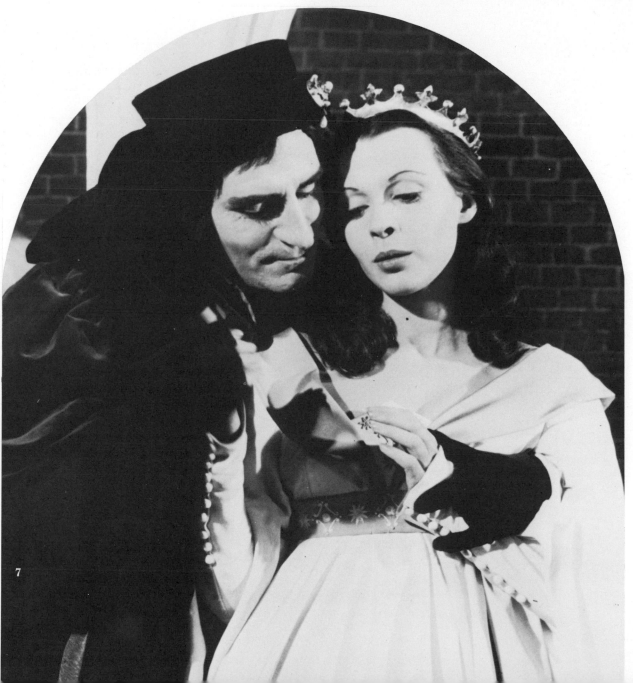

7

RICHARD:

Was ever woman in this humour woo'd?
Was ever woman in this humour won?
I'll have her, but I will not keep her long.
What? I that kill'd her Husband, and his Father,
To take her in her heart's extremest hate,
With curses in her mouth, tears in her eyes,
The bleeding witness of my hatred by,
Having God, her conscience, and these bars against me,
And I, no friends to back my suit withal,
But the plain Devil, and dissembling looks?
And yet to win her? All the world to nothing.
Hah!

ACT I SCENE II

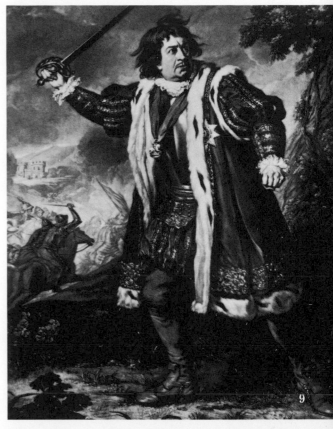

8
Richard III: Brian Bedford
Lady Anne: Martha Henry
Stratford Ontario Canada 1977
Director: Robin Phillips

9
Richard III: David Garrick
(1717–1799)

10
Richard III: Frank Benson
Prince of Wales: Miss A. P. Nicholson
Duke of York: Molly Temaine
Stratford 1906
Director: Frank Benson

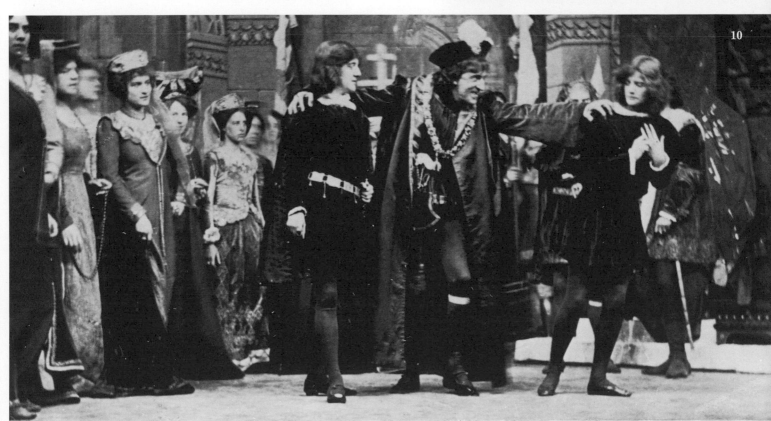

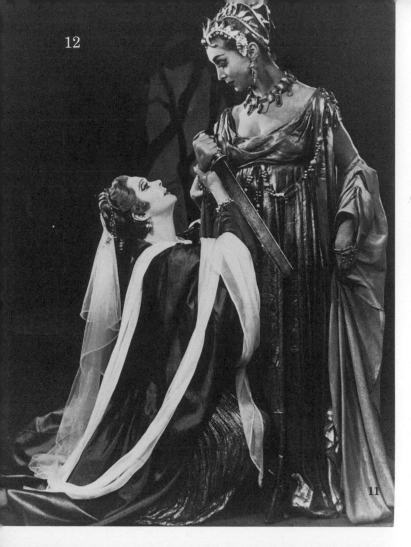

Titus Andronicus

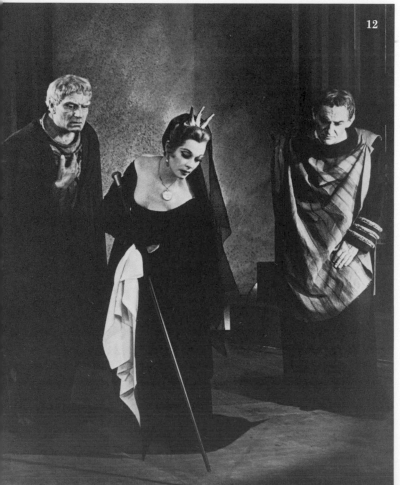

TITUS:

Speak Lavinia, what accursed hand,
Hath made thee handless in thy father's fight?
What fool hath added water to the sea?
Or brought a faggot to bright burning Troy?
My grief was at the height before thou cam'st.

ACT III SCENE I

11
Lavinia: Vivien Leigh
Tamora: Maxine Audley

12
Titus: Laurence Olivier
Lavinia: Vivien Leigh
Marcus: Alan Webb

13
Aaron: Anthony Quayle

Stratford 1955
Director: Peter Brook

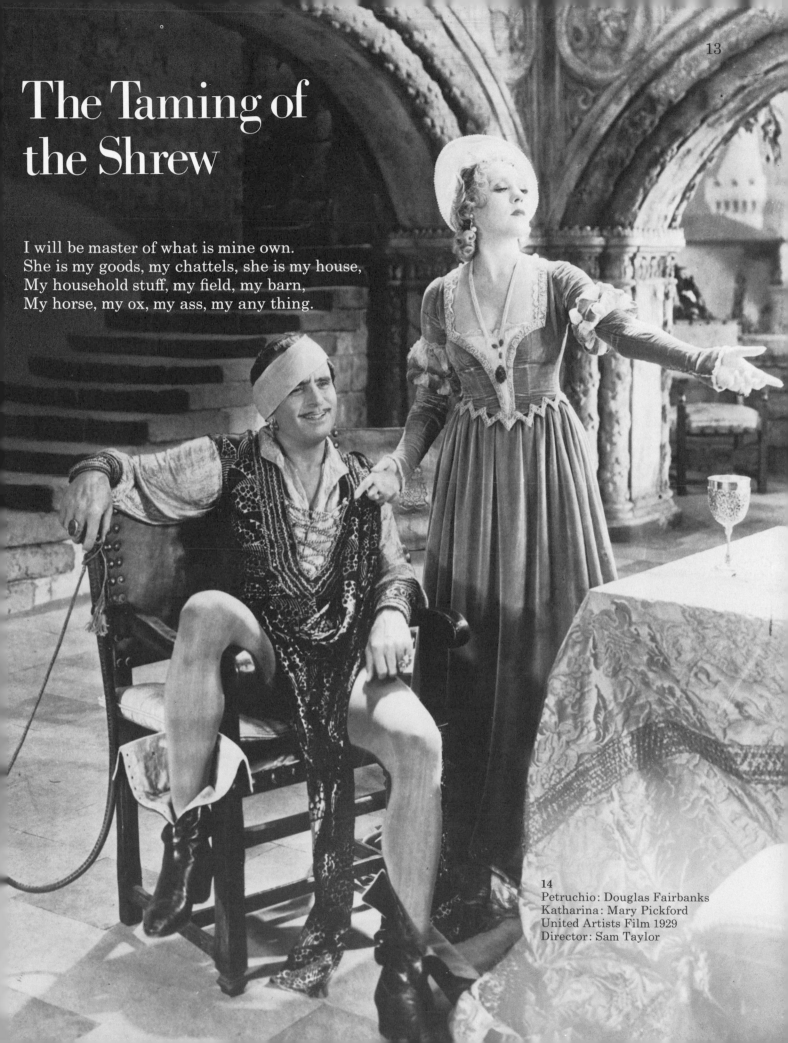

The Taming of the Shrew

I will be master of what is mine own.
She is my goods, my chattels, she is my house,
My household stuff, my field, my barn,
My horse, my ox, my ass, my any thing.

14
Petruchio: Douglas Fairbanks
Katharina: Mary Pickford
United Artists Film 1929
Director: Sam Taylor

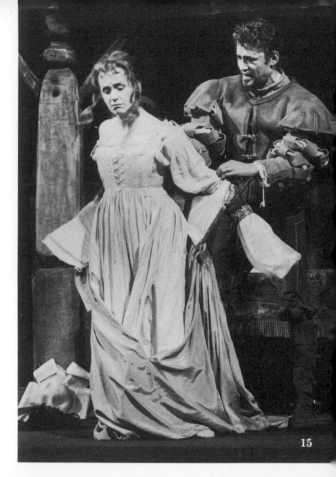

PETRUCHIO:

I am as peremptory as she proud minded:
And where two raging fires meet together,
They do consume the thing that feeds their fury.
Though little fire grows great with little wind,
Yet extreme gusts will blow out fire and all:
So I to her, and so she yields to me,
For I am rough, and woo not like a babe.
ACT II SCENE I

15

16

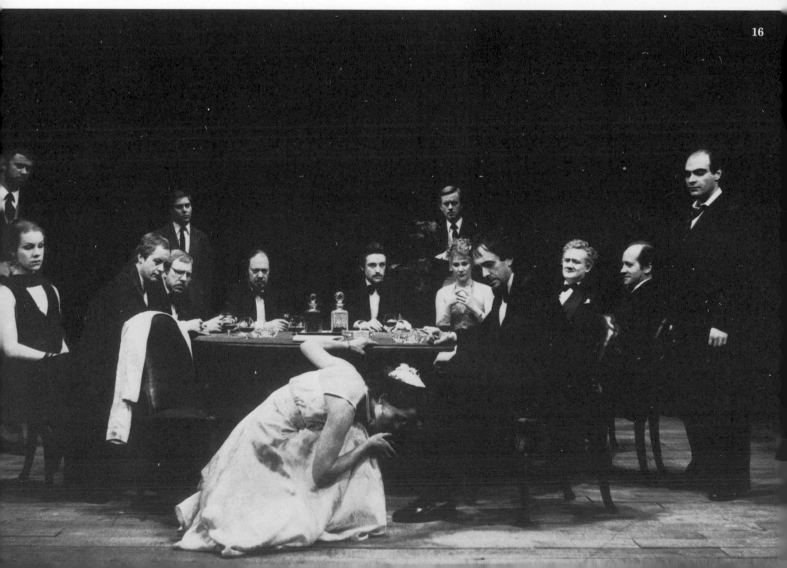

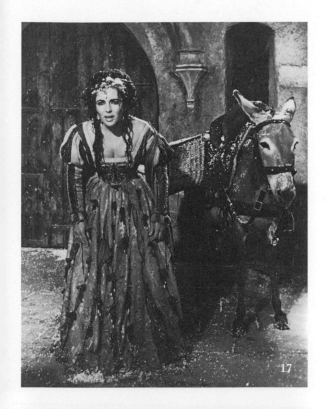

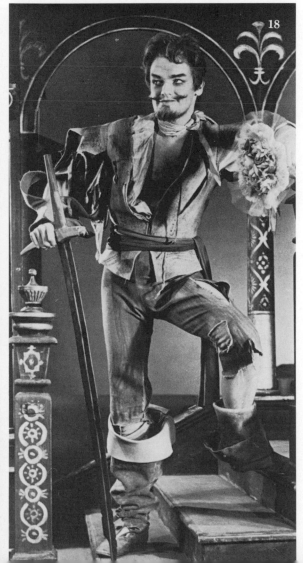

KATHARINA:

Thy husband is thy Lord, thy life, thy keeper,
Thy head, thy sovereign: one that cares for thee,
And for thy maintenance. Commits his body
To painful labour, both by sea and land:
To watch the night in storms, the day in cold,
Whilst thou liest warm at home, secure and safe,
And craves no other tribute at thy hands,
But love, fair looks, and true obedience;
Too little payment for so great a debt.
Such duty as the subject owes the Prince,
Even such a woman oweth to her husband:
And when she's froward, peevish, sullen, sour,
And not obedient to his honest will,
What is she but a foul contending rebel,
And graceless traitor to her loving Lord?
I am asham'd that women are so simple
To offer war, where they should kneel for peace:
Or seek for rule, supremacy, and sway,
When they are bound to serve, love, and obey.
Why are our bodies soft, and weak, and smooth,
Unapt to toil and trouble in the world,
But that our soft conditions, and our hearts,
Should well agree with our external parts?

ACT V SCENE II

15
Petruchio: Peter O'Toole
Katharina: Peggy Ashcroft
RSC Stratford 1960
Director: John Barton

16
Katharina: Paola Dionisotti
Petruchio: Jonathan Pryce
RSC Aldwych 1979
Director: Michael Bogdanov

17
Katharina: Elizabeth Taylor
Columbia Film 1967
Director: Franco Zeffirelli

18
Petruchio: Keith Michell
Stratford 1954
Director: George Devine

The Two Gentlemen of Verona

In love, who respects friends?

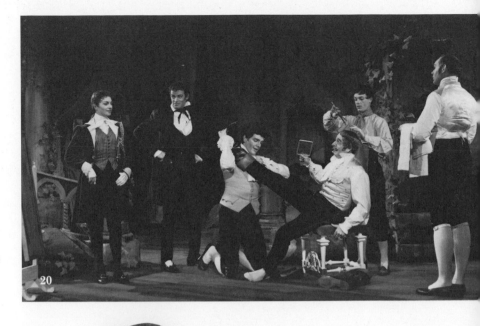

Song

Who is Silvia? What is she,
 That all our swains commend her?
Holy, fair, and wise is she;
 The heaven such grace did lend her,
That she might admired be.

Is she kind as she is fair?
 For beauty lives with kindness:
Love doth to her eyes repair,
 To help him of his blindness:
And, being helped, inhabits there.

Then to Silvia, let us sing,
 That Silvia is excelling;
She excels each mortal thing,
 Upon the dull earth dwelling.
To her let us garlands bring.
ACT IV SCENE II

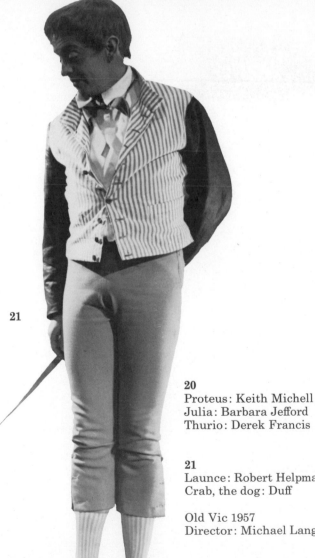

20
Proteus: Keith Michell
Julia: Barbara Jefford
Thurio: Derek Francis

21
Launce: Robert Helpmann
Crab, the dog: Duff

Old Vic 1957
Director: Michael Langham

19
Julia: Helen Mirren
Proteus: Ian Richardson
RSC Stratford 1970
Director: Robin Phillips

Love's Labour's Lost

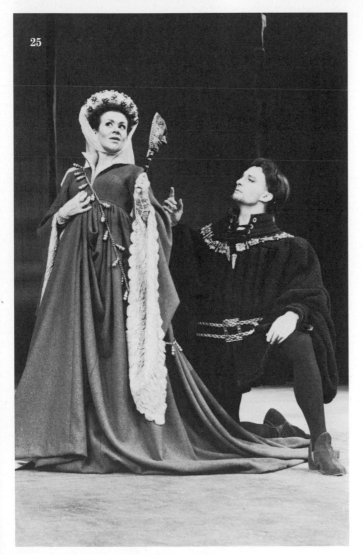

22
Berowne (signing): Michael Redgrave
New 1949 (Old Vic Production)
Director: Hugh Hunt

23
Don Armado: Paul Scofield
Stratford 1946
Director: Peter Brook

24
Maria: Dilys Hamlett
Prince: Geraldine McEwan
Costard: Clive Revill
Katharine: Greta Watson
Rosaline: Jeannette Sterke
Stratford 1956
Director: Peter Hall

25
Berowne: Jeremy Brett
Rosaline: Joan Plowright
National 1969
Director: Laurence Olivier

BEROWNE:

Taffeta phrases, silken terms precise,
Three-pil'd hyperboles, spruce affection,
Figures pedantical; these summer flies
Have blown me full of maggot ostentation.

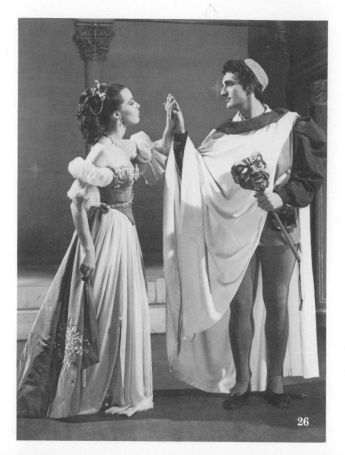

26

Romeo and Juliet

a pair of star-cross'd lovers

26
Romeo: Alan Badel
Juliet: Claire Bloom
Old Vic 1952
Director: Hugh Hunt

27
Romeo: John Stride
Juliet: Judi Dench
Old Vic 1960
Director: Franco Zeffirelli

28
Romeo: Matheson Lang
Juliet: Nora Kerin
Lyceum 1908
Director: Matheson Lang

29
Juliet: Peggy Ashcroft
Nurse: Edith Evans
OUDS Oxford 1932
New 1935
Director: John Gielgud

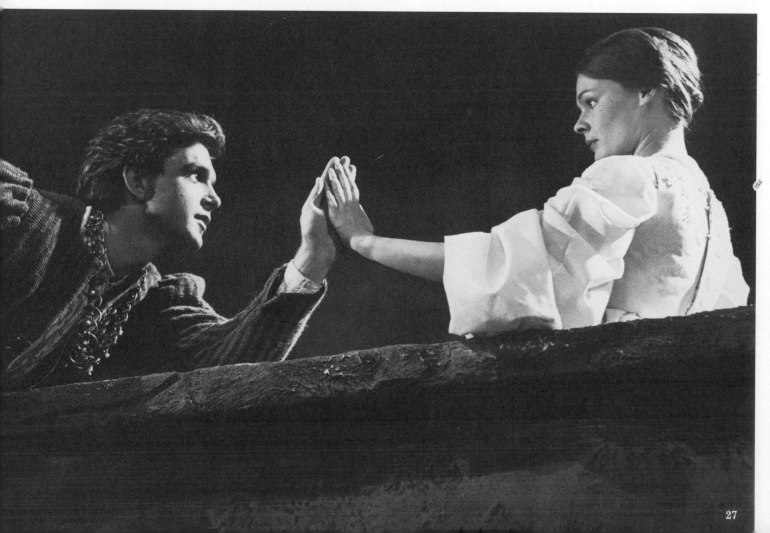

27

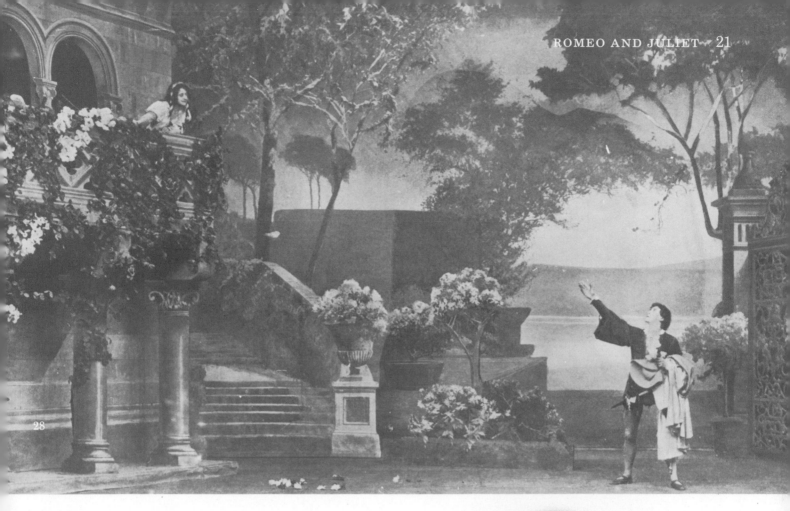

JULIET:

O Romeo, Romeo, wherefore art thou Romeo?
Deny thy father and refuse thy name.
Or if thou wilt not, be but sworn my love,
And I'll no longer be a Capulet.

ROMEO:

Shall I hear more, or shall I speak at this?

JULIET:

'Tis but thy name that is my enemy:
Thou art thyself, though not a Montague,
What's Montague? It is nor hand nor foot,
Nor arm nor face, nor any other part
Belonging to a man. O be some other name.
What's in a name? That which we call a rose,
By any other name would smell as sweet,
So Romeo would were he not Romeo call'd,
Retain that dear perfection which he owes,
Without that title. Romeo doff thy name,
And for thy name which is no part of thee,
Take all my self.

ACT II SCENE IV

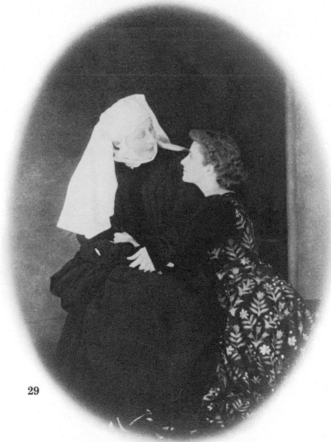

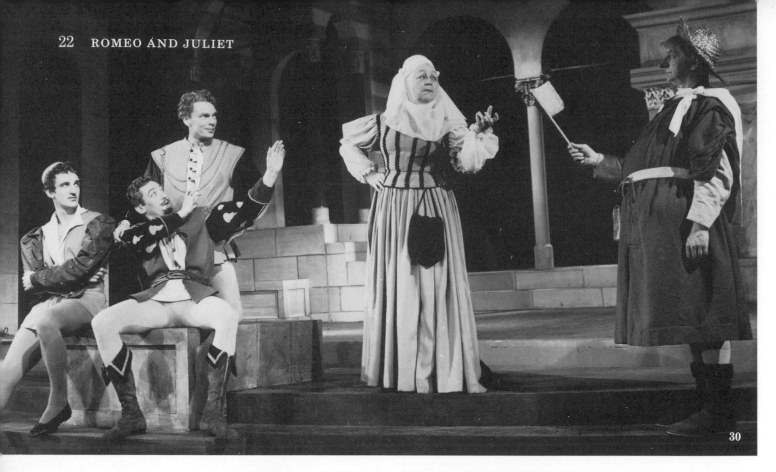

30

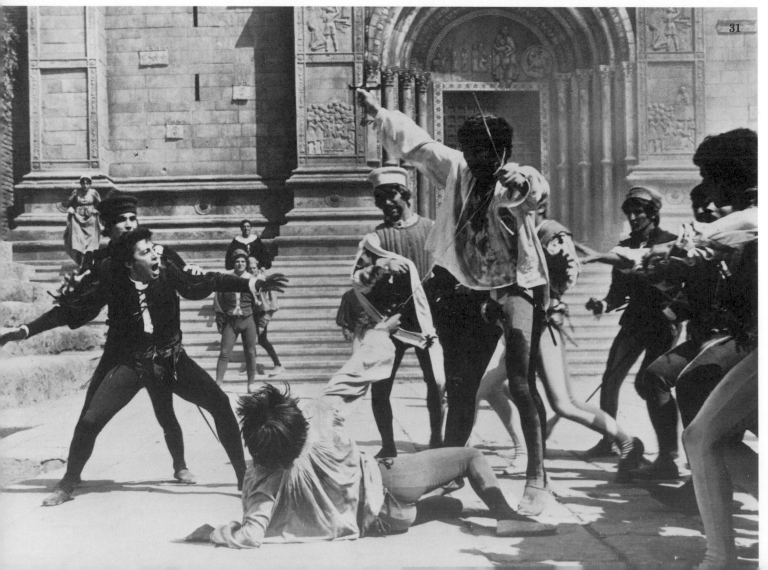

31

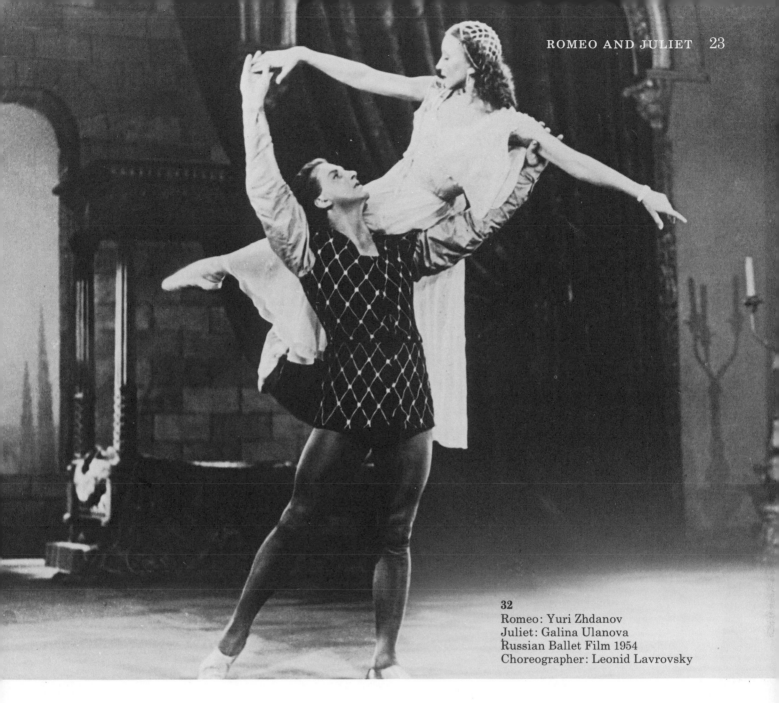

32
Romeo: Yuri Zhdanov
Juliet: Galina Ulanova
Russian Ballet Film 1954
Choreographer: Leonid Lavrovsky

30
Romeo: Alan Badel
Mercutio: Peter Finch
Benvolio: William Squire
Nurse: Athene Seyler
Peter: Newton Blick
Old Vic 1952
Director: Hugh Hunt

31
The Franco Zeffirelli 1968
Paramount Film

JULIET:

Come night, come Romeo, come thou day in night,
For thou wilt lie upon the wings of night,
Whiter than new snow on a raven's back:
Come gentle night, come loving black-brow'd night,
Give me my Romeo, and when he shall die,
Take him and cut him out in little stars,
And he will make the face of heaven so fine,
That all the world will be in love with night,
And pay no worship to the garish Sun.
ACT III SCENE II

33

ROMEO:

Ah dear Juliet
Why art thou yet so fair? Shall I believe
That unsubstantial death is amorous,
And that the lean abhorred monster keeps
Thee here in dark to be his paramour?
For fear of that I still will stay with thee,
And never from this palace of dim night
Depart again: here, here will I remain,
With worms that are thy chamber-maids: O here
Will I set up my everlasting rest:
And shake the yoke of inauspicious stars,
From this world-wearied flesh: eyes look your last:
Arms take your last embrace: and lips, O you
The doors of breath, seal with a righteous kiss
A dateless bargain to engrossing death:
Come bitter conduct, come unsavoury guide,
Thou desperate pilot, now at once run on
The dashing rocks, thy sea-sick weary bark:
Here's to my love. O true apothecary:
Thy drugs are quick. Thus with a kiss I die.

ACT V SCENE III

33
Romeo: Johnston Forbes-Robertson
Juliet: Mrs. Patrick Campbell
Lyceum 1895
Director: Johnston Forbes-Robertson

34
Romeo: Rudolf Nureyev
Juliet: Margot Fonteyn
Covent Garden Royal Ballet 1968
Choreographer: Kenneth Macmillan

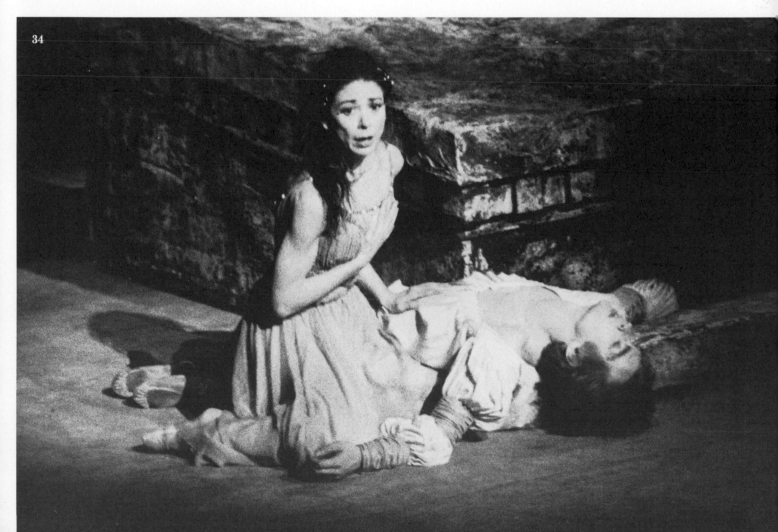

34

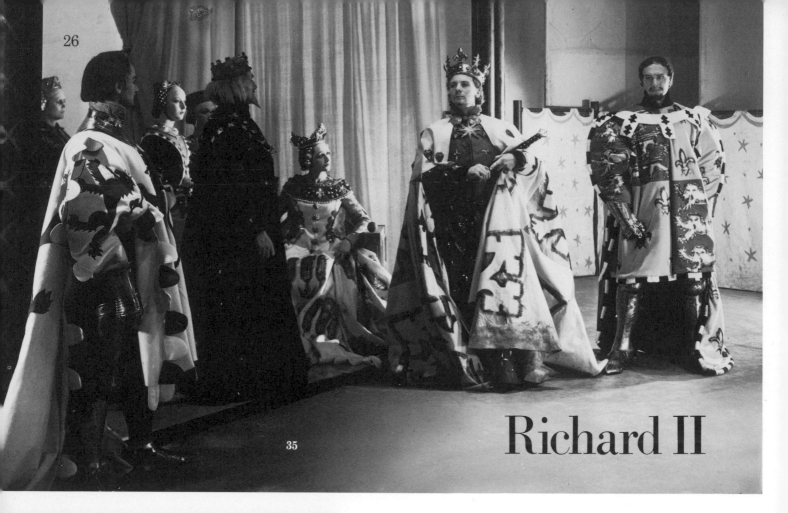

35

Richard II

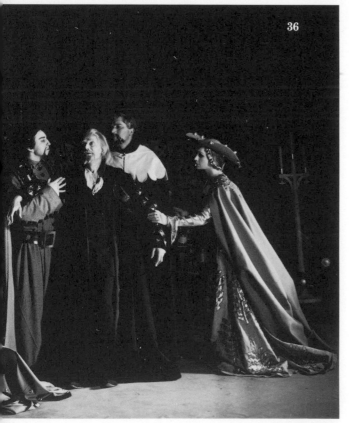

36

GAUNT:

This royal Throne of Kings, this scepter'd Isle,
This earth of Majesty, this seat of Mars,
This other Eden, demi-paradise,
This Fortress built by Nature for herself,
Against infection, and the hand of war:
This happy breed of men, this little world,
This precious stone, set in the silver sea,
Which serves it in the office of a wall,
Or as a moat defensive to a house,
Against the envy of less happier Lands,
This blessed plot, this earth, this Realm, this England.
ACT II SCENE I

35 36
Richard II: John Gielgud
Bolingbroke: Michael Redgrave
Mowbray: Glen Byam Shaw
Gaunt: Leon Quartermaine
Queen: Peggy Ashcroft
Queen's 1937
Director: John Gielgud

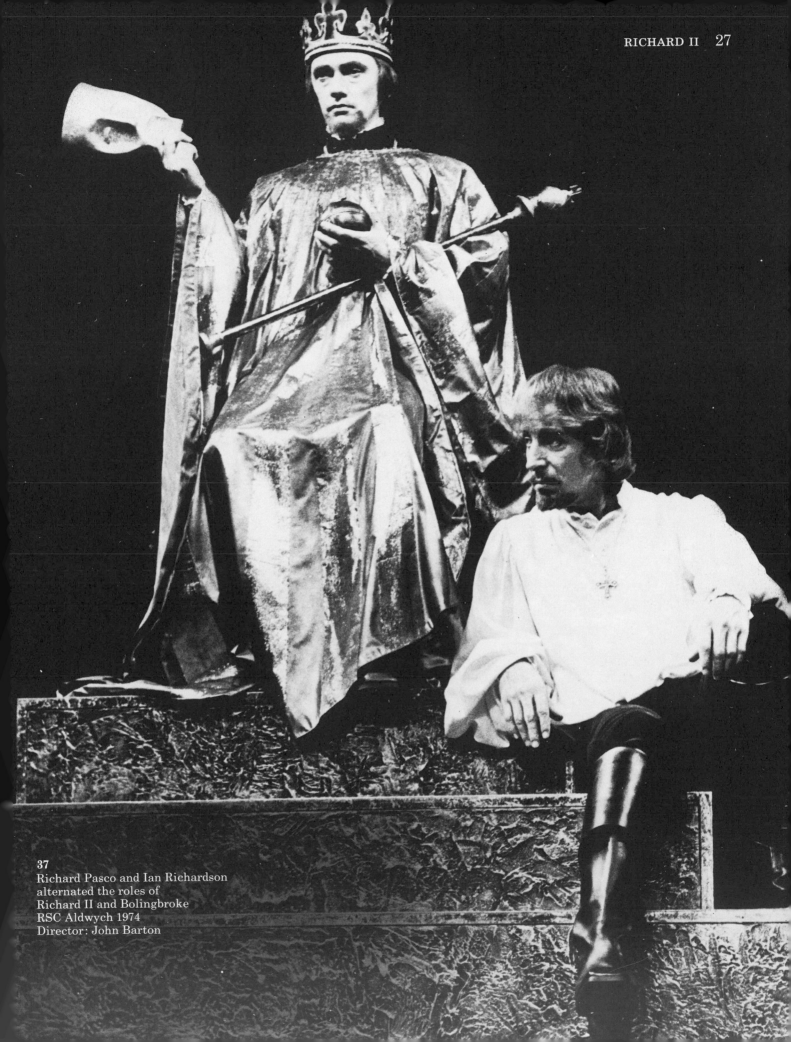

37
Richard Pasco and Ian Richardson
alternated the roles of
Richard II and Bolingbroke
RSC Aldwych 1974
Director: John Barton

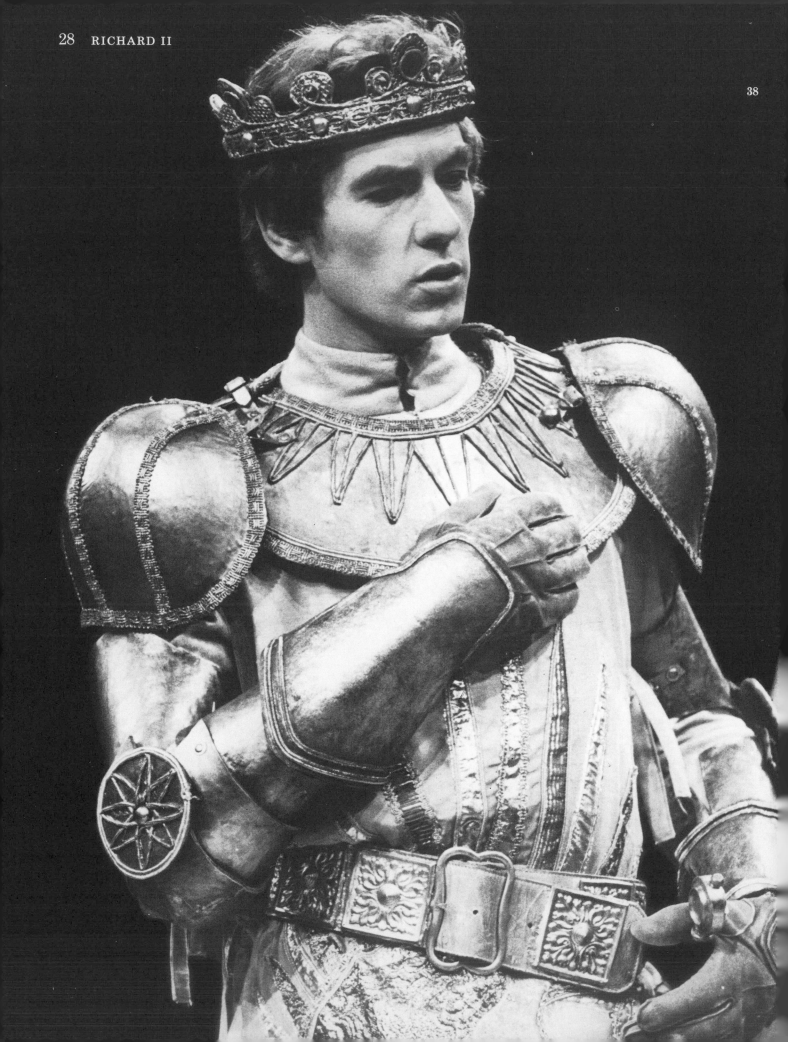

RICHARD:

Let's talk of graves, of worms, and epitaphs,
Make dust our paper, and with rainy eyes
Write sorrow on the bosom of the earth.
Let's choose executors, and talk of wills:
And yet not so; for what can we bequeath,
Save our deposed bodies to the ground?
Our lands, our lives, and all are Bolingbroke's,
And nothing can we call our own, but Death,
And that small model of the barren Earth,
Which serves as paste, and cover to our bones:
For God's sake let us sit upon the ground,
And tell sad stories of the death of Kings:
How some have been depos'd, some slain in war,
Some haunted by the ghosts they have depos'd,
Some poison'd by their wives, some sleeping kill'd,
All murther'd. For within the hollow Crown
That rounds the mortal temples of a King,
Keeps Death his Court, and there the Antic sits
Scoffing his state, and grinning at his pomp,
Allowing him a breath, a little scene,
To monarchize, be fear'd, and kill with looks,
Infusing him with self and vain conceit,
As if this flesh, which walls about our life,
Were brass impregnable: and humour'd thus,
Comes at the last, and with a little pin
Bores through his castle wall, and farewell King.
Cover your heads, and mock not flesh and blood
With solemn reverence: throw away respect,
Tradition, form, and ceremonious duty,
For you have but mistook me all this while:
I live with bread like you, feel want,
Taste grief, need friends: subjected thus,
How can you say to me, I am a King?

ACT III SCENE II

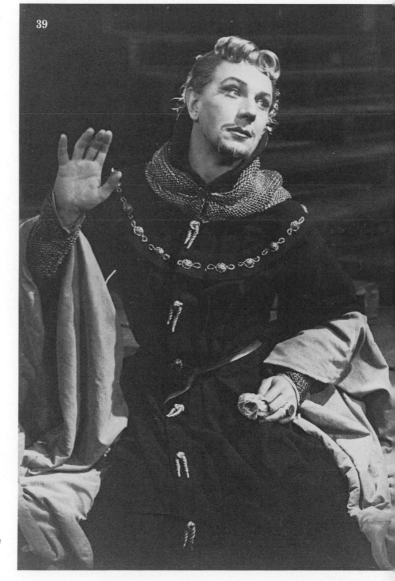

39

38
Richard II: Ian McKellen
Prospect 1969
Director: Richard Cottrell

39
Richard II: Michael Redgrave
Stratford 1951
Director: Anthony Quayle

King John

Mad world! mad kings! mad composition!

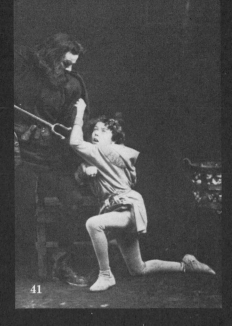

41
Hubert: Franklin McLeay
Arthur: Charles Sefton
Her Majesty's 1899
Director: Herbert Beerbohm Tree

42
King John: Robert Helpmann
Stratford 1948
Director: Michael Benthall

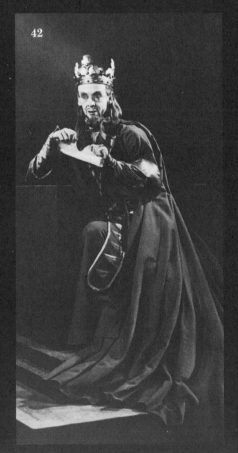

40
King John: Emrys James
Pandulph: Jeffery Dench
RSC Aldwych 1975
Director: John Barton
with Barry Kyle

A Midsummer Night's Dream

My Oberon, what visions have I seen!
Methought I was enamour'd of an ass.

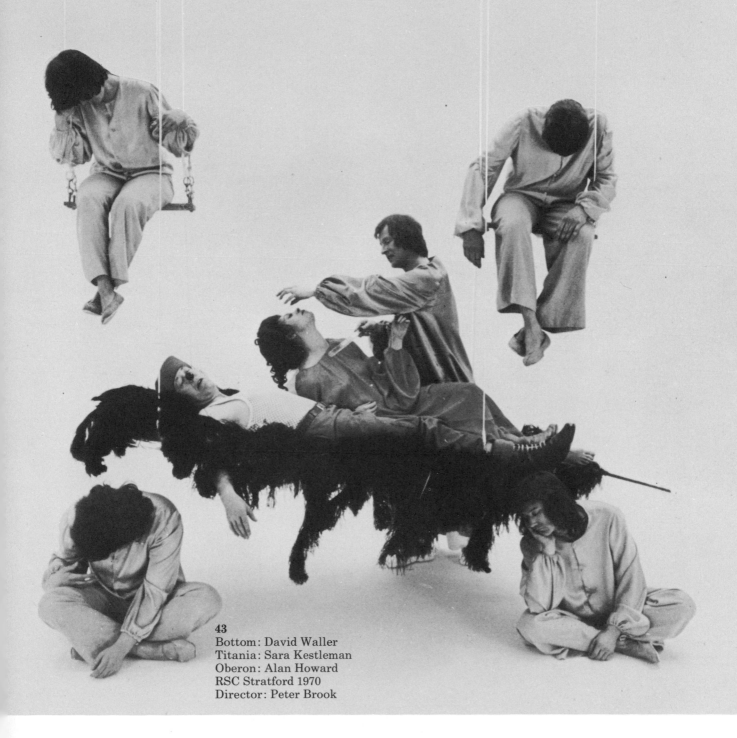

43
Bottom: David Waller
Titania: Sara Kestleman
Oberon: Alan Howard
RSC Stratford 1970
Director: Peter Brook

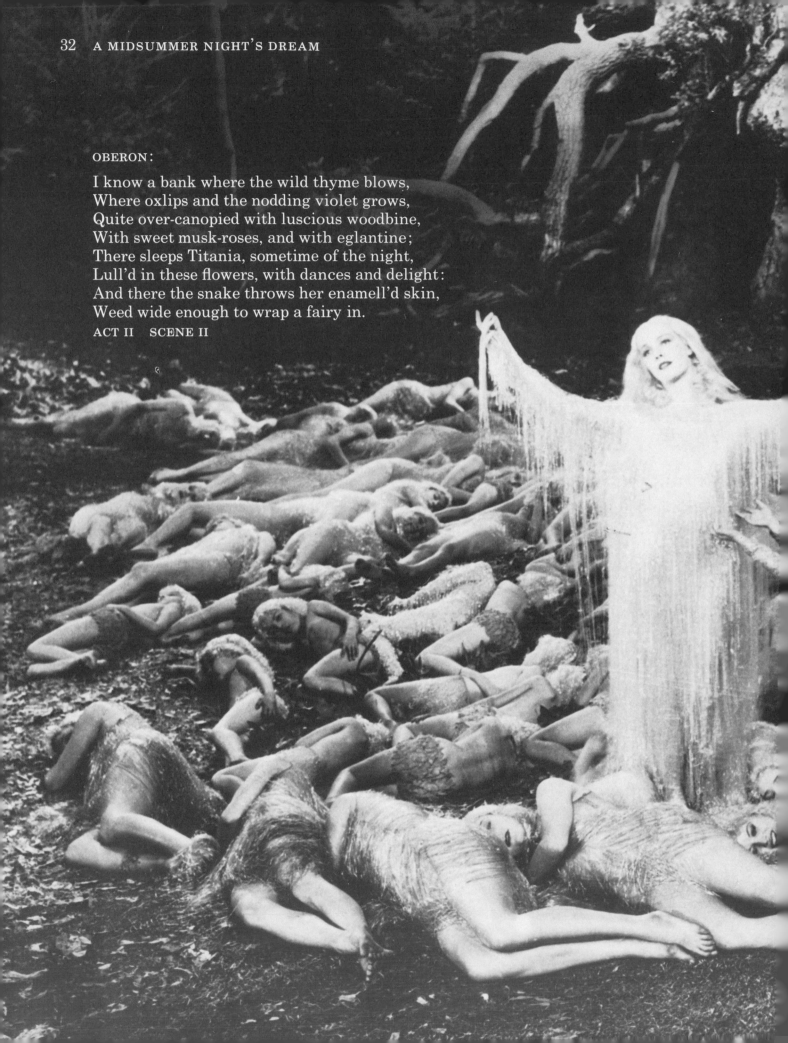

OBERON:

I know a bank where the wild thyme blows,
Where oxlips and the nodding violet grows,
Quite over-canopied with luscious woodbine,
With sweet musk-roses, and with eglantine;
There sleeps Titania, sometime of the night,
Lull'd in these flowers, with dances and delight:
And there the snake throws her enamell'd skin,
Weed wide enough to wrap a fairy in.
ACT II SCENE II

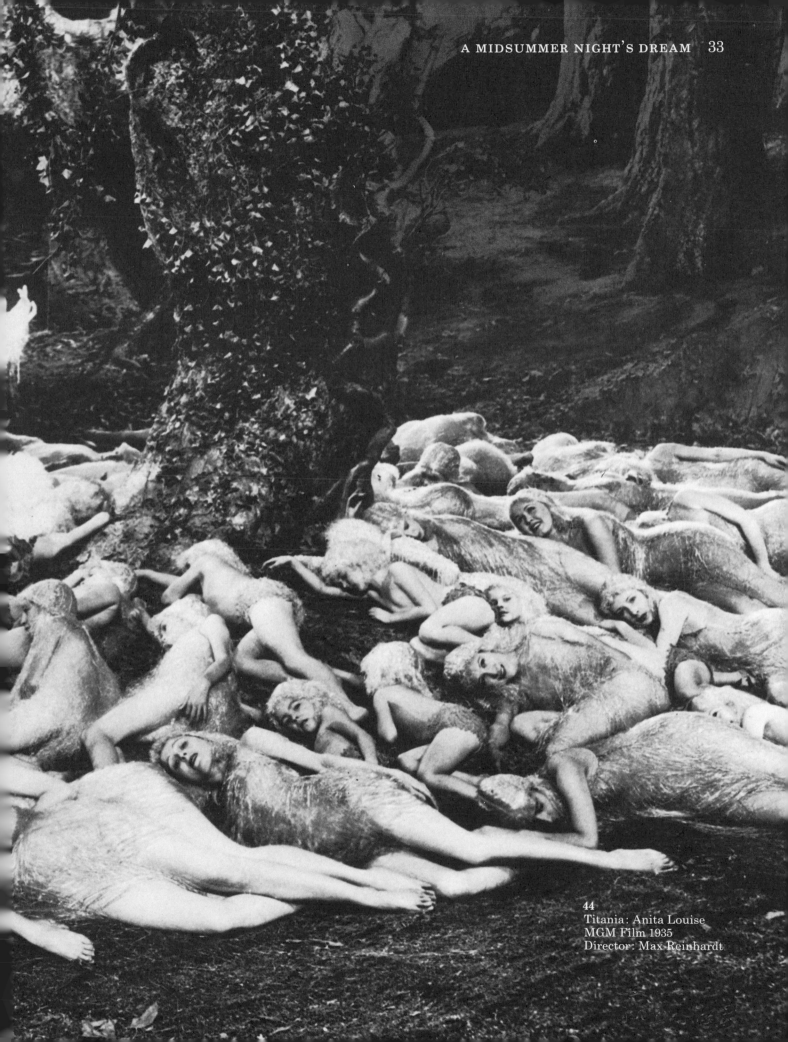

44
Titania: Anita Louise
MGM Film 1935
Director: Max Reinhardt

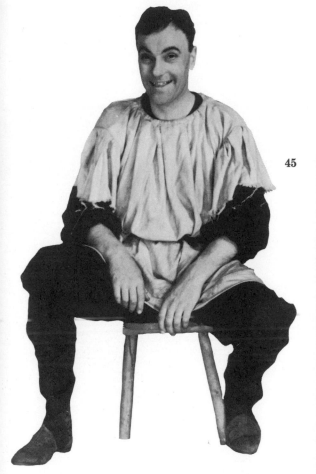

45

BOTTOM:

I have had a most rare vision. I have had a dream, past the wit of man, to say, what dream it was. Man is but an ass, if he go about to expound this dream. Methought I was, there is no man can tell what. Methought I was, and methought I had. But man is but a patch'd fool, if he will offer to say, what methought I had. The eye of man hath not heard, the ear of man hath not seen, man's hand is not able to taste, his tongue to conceive, nor his heart to report, what my dream was. I will get Peter Quince to write a ballad of this dream, it shall be called *Bottom's Dream*, because it hath no bottom: and I will sing it in the latter end of a play, before the Duke. Peradventure, to make it the more gracious, I shall sing it at her death.

ACT IV SCENE I

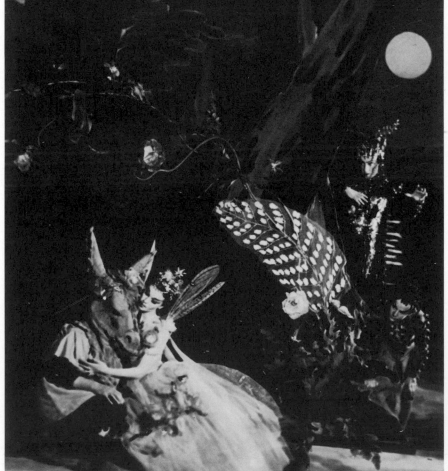

46

45 46
Bottom: Ralph Richardson
Titania: Vivien Leigh
Oberon: Robert Helpmann
Old Vic 1937
Director: John Gielgud

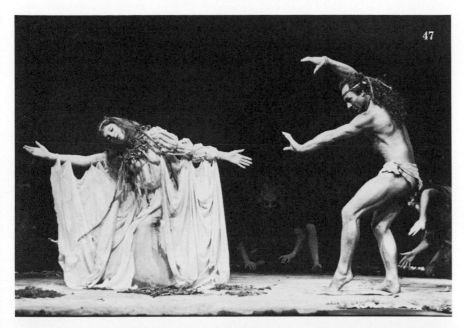

47
Titania: Marjorie Bland
Oberon: Patrick Stewart
RSC Aldwych 1977
Directors: John Barton
and Gillian Lynne

48
Starveling (Moonshine): Peter Duguid
Flute (Thisbe): Ian Bannen
Bottom (Pyramus): Anthony Quayle
Snout (Wall): James Grout
Snug (Lion): Mervyn Blake
Quince (Prologue): Leo McKern
Stratford 1954
Director: George Devine

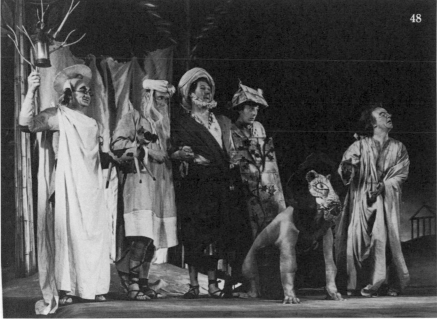

49
Puck: Mickey Rooney
Hermia: Olivia de Havilland
MGM Film 1935
Director: Max Reinhardt

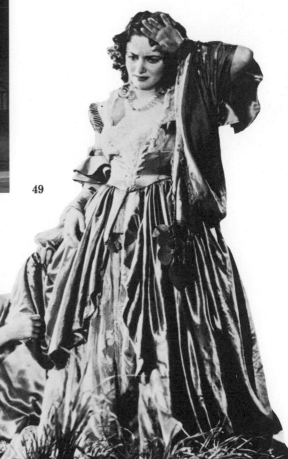

PUCK:

Lord, what fools these mortals be!

My daughter, O my ducats, O my daughter,
Fled with a Christian, O my Christian ducats!

The Merchant of Venice

SHYLOCK:

I am a Jew: hath not a Jew eyes? hath not a Jew hands, organs, dimensions, senses, affections, passions, fed with the same food, hurt with the same weapons, subject to the same diseases, healed by the same means, warmed and cooled by the same winter and summer as a Christian is: if you prick us do we not bleed? if you tickle us do we not laugh? if you poison us do we not die? and if you wrong us shall we not revenge? if we are like you in the rest, we will resemble you in that. If a Jew wrong a Christian, what is his humility, revenge! If a Christian wrong a Jew, what should his sufferance be by Christian example, why revenge! The villainy you teach me I will execute, and it shall go hard but I will better the instruction.

ACT III SCENE I

50
Shylock: Henry Irving
Lyceum 1897
Director: Henry Irving

51
Shylock: Robert Helpmann
Jessica: Heather Stannard
Stratford 1948
Director: Michael Benthall

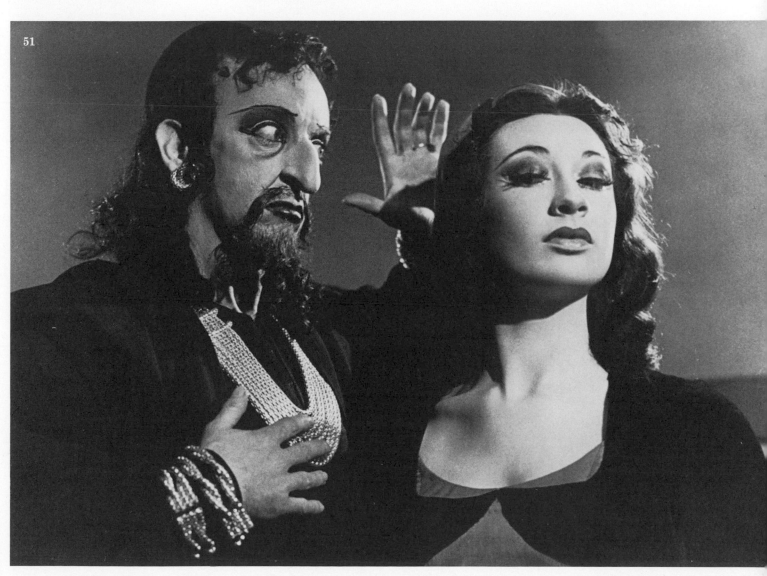

51

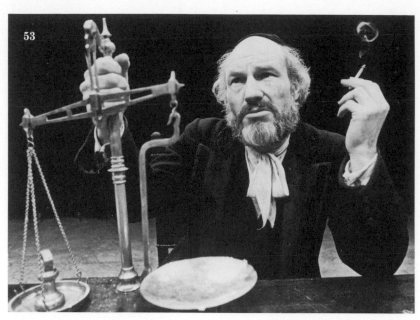

52
Shylock: William Charles Macready
1839

53
Shylock: Patrick Stewart
RSC Warehouse 1979
Director: John Barton

54
Portia: Dorothy Tutin
Bassanio: Denholm Elliot
RSC Stratford 1960
Director: Michael Langham

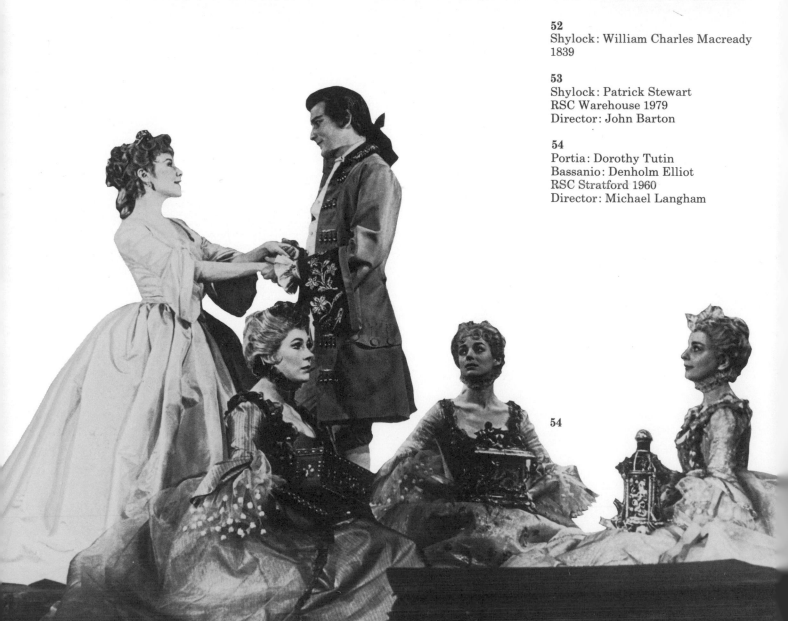

55
Shylock: Laurence Olivier
Portia: Joan Plowright
Duke: Benjamin Whitrow
National 1970
Director: Jonathan Miller

56
Portia: Ellen Terry
Lyceum 1897
Director: Henry Irving

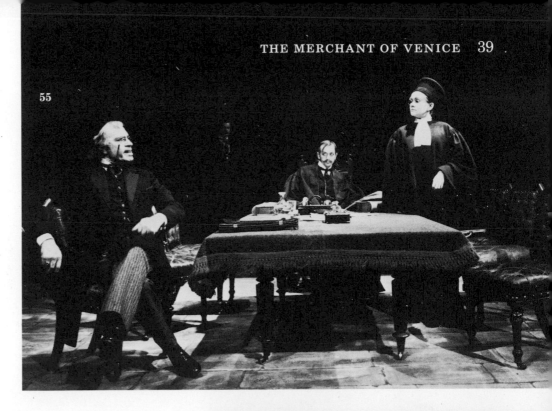

55

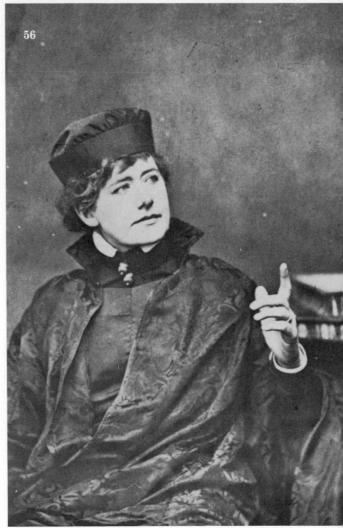

56

PORTIA:
Then must the Jew be merciful.
SHYLOCK:
On what compulsion must I? Tell me that.
PORTIA:
The quality of mercy is not strain'd,
It droppeth as the gentle rain from heaven
Upon the place beneath. It is twice blest,
It blesseth him that gives, and him that takes,
'Tis mightiest in the mightiest, it becomes
The throned Monarch better than his Crown.
His Sceptre shows the force of temporal power,
The attribute to awe and majesty,
Wherein doth sit the dread and fear of Kings:
But mercy is above this sceptred sway,
It is enthroned in the hearts of Kings,
It is an attribute to God himself;
And earthly power doth then show likest God's
When mercy seasons Justice. Therefore Jew,
Though Justice be thy plea, consider this,
That in the course of Justice, none of us
Should see salvation: we do pray for mercy,
And that same prayer, doth teach us all to render
The deeds of mercy. I have spoke thus much
To mitigate the justice of thy plea:
Which if thou follow, this strict Court of Venice
Must needs give sentence 'gainst the Merchant there.

ACT IV SCENE I

Much Ado About Nothing

57

There is a kind of merry war betwixt Signior Benedick and her, they never meet but there's a skirmish of wit between them.

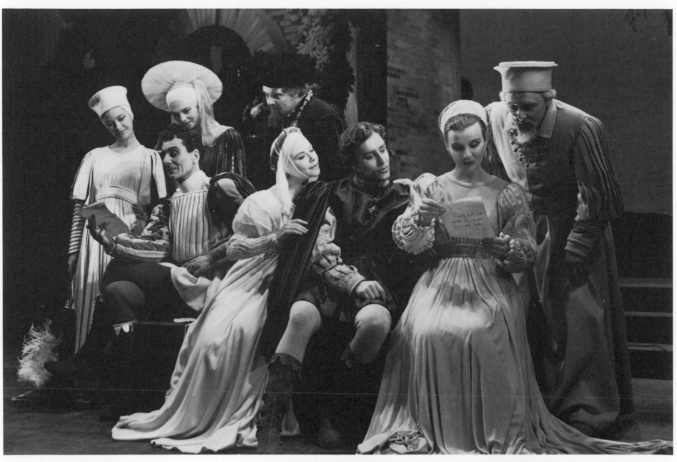

58

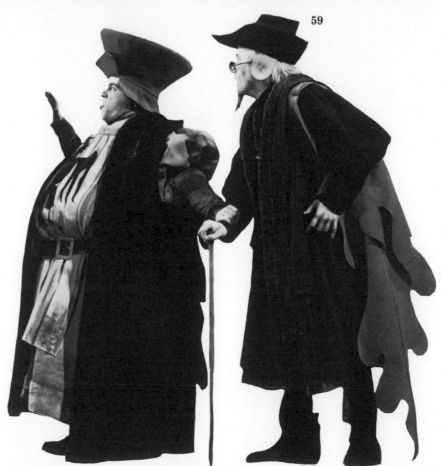

59

57
Beatrice: Diana Wynyard
Benedick: John Gielgud

58
Benedick: John Gielgud
Hero: Dorothy Tutin
Claudio: Robert Hardy
Beatrice: Diana Wynyard
Leonato: Lewis Casson

59
Dogberry: George Rose
Verges: John Moffatt

Phoenix 1952 (Stratford Production)
Director: John Gielgud

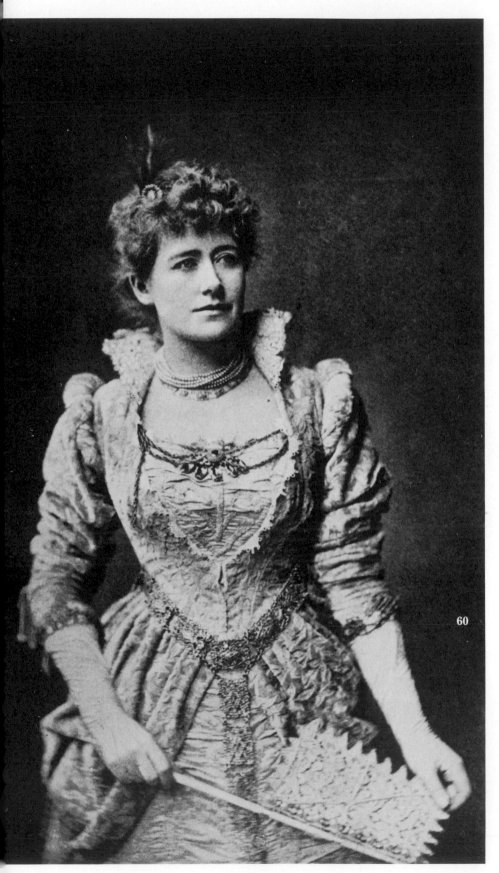

60

Song

Sigh no more, ladies, sigh no more;
 Men were deceivers ever;
One foot in sea, and one on shore,
 To one thing constant never:
Then sigh not so, but let them go,
 And be you blithe and bonny,
Converting all your sounds of woe
 Into Hey nonny, nonny.

Sing no more ditties, sing no more,
 Of dumps so dull and heavy;
The fraud of men was ever so,
Since summer first was leavy:
Then sigh not so, but let them go,
 And be you blithe and bonny,
Converting all your sounds of woe
 Into Hey nonny, nonny.

ACT II SCENE III

60
Beatrice: Ellen Terry
Lyceum 1882
Director: Henry Irving

61
Beatrice: Judi Dench
Benedick: Donald Sinden
RSC Aldwich 1977
Director: John Barton

BENEDICK:

No, the world must be peopled. When I said I would die a
bachelor, I did not think I should live till I were married.

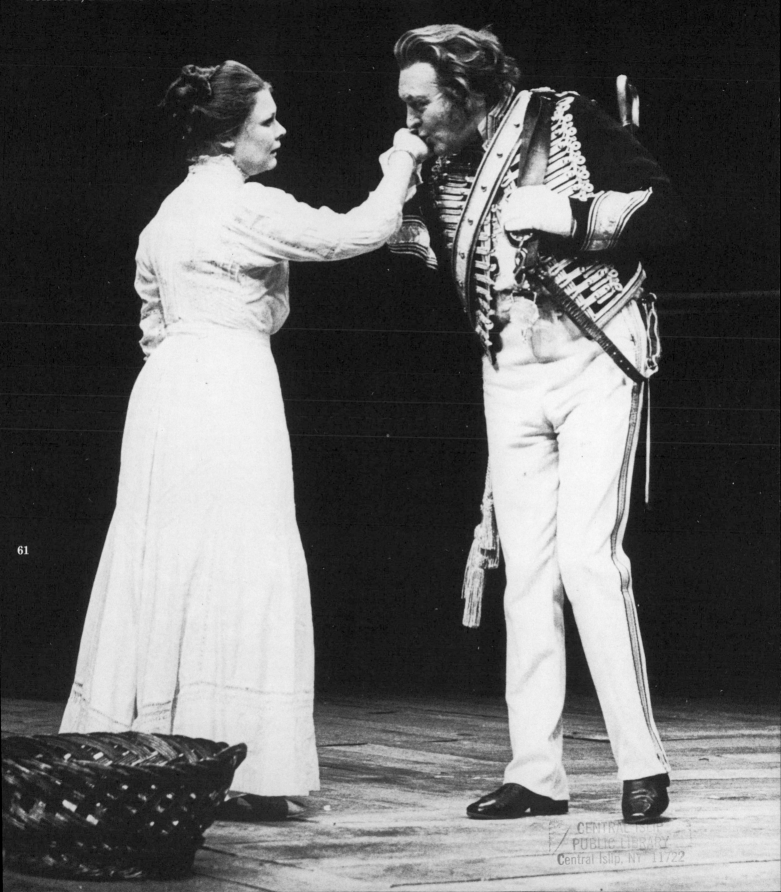

61

Henry IV

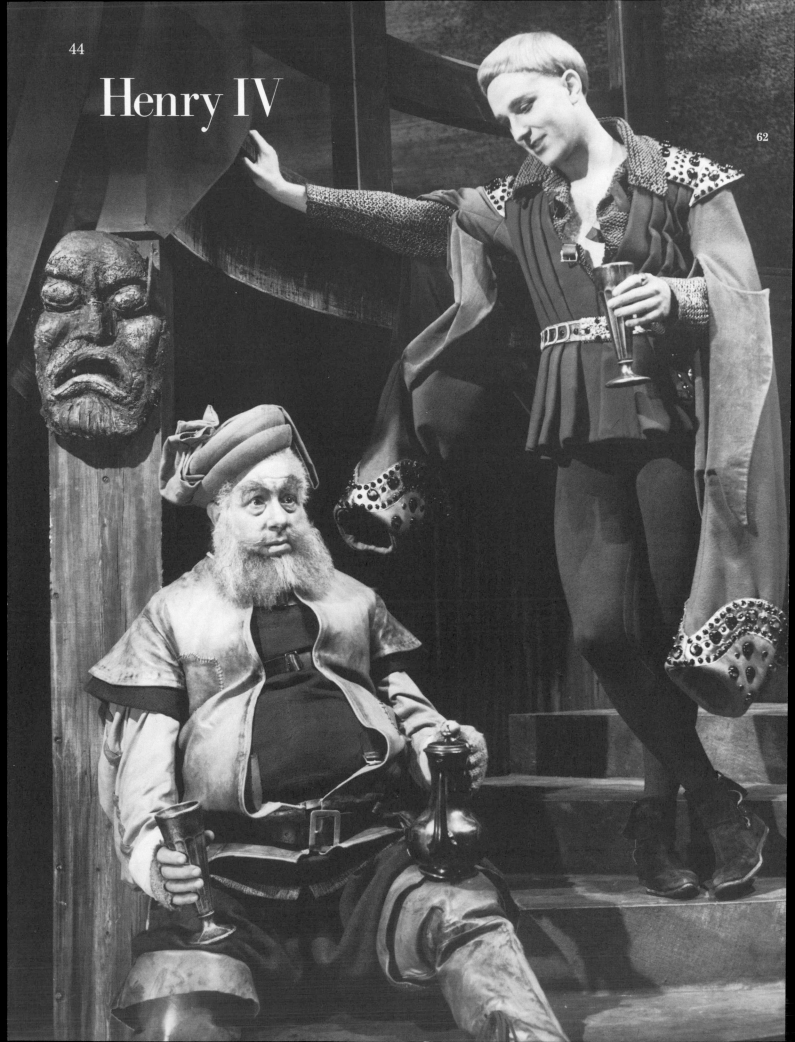

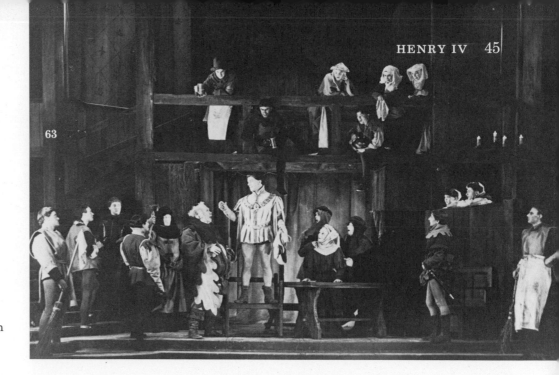

62
Falstaff: Paul Rogers
Prince Hal: Robert Hardy
Old Vic 1955
Director: Douglas Seale

63
Falstaff: Anthony Quayle
Prince Hal: Richard Burton
Mistress Quickly: Rosalind Atkinson
Stratford 1951
Director: Michael Redgrave

PRINCE:

There is a devil haunts thee in the likeness of an old fat man, a tun of man is thy
companion: why dost thou converse with that trunk of humours, that boltinghutch of
beastliness, that swoll'n parcel of dropsies, that huge bombard of sack, that stuff'd cloak-
bag of guts, that roasted Manningtree ox with the pudding in his belly, that reverend vice,
that grey iniquity, that father ruffian, that vanity in years, wherein is he good, but to taste
sack and drink it? wherein neat and cleanly, but to carve a capon and eat it? wherein
cunning, but in craft? wherein crafty, but in villainy? wherein villainous, but in all
things? wherein worthy, but in nothing?

FALSTAFF:

I would your grace would take me with you, whom means your grace?

PRINCE:

That villainous abominable misleader of youth, Falstaff, that old white bearded Satan.

FALSTAFF:

My Lord, the man I know.

PRINCE:

I know thou dost.

FALSTAFF:

But to say I know more harm in him than in myself, were to say more than I know: that he
is old the more the pity, his white hairs do witness it, but that he is saving your reverence,
a whoremaster, that I utterly deny: if sack and sugar be a fault, God help the wicked: if to
be old and merry be a sin, then many an old host that I know is damn'd: If to be fat be to be
hated, then Pharaoh's lean kine are to be loved. No my good Lord banish Peto, banish
Bardolph, banish Poins, but for sweet Jack Falstaff, kind Jack Falstaff, true Jack Falstaff,
valiant Jack Falstaff and therefore more valiant being as he is old Jack Falstaff, banish
not him thy Harry's company, banish not him thy Harry's company, banish plump Jack,
and banish all the world.

PRINCE:

I do, I will.

PART I ACT II SCENE IV

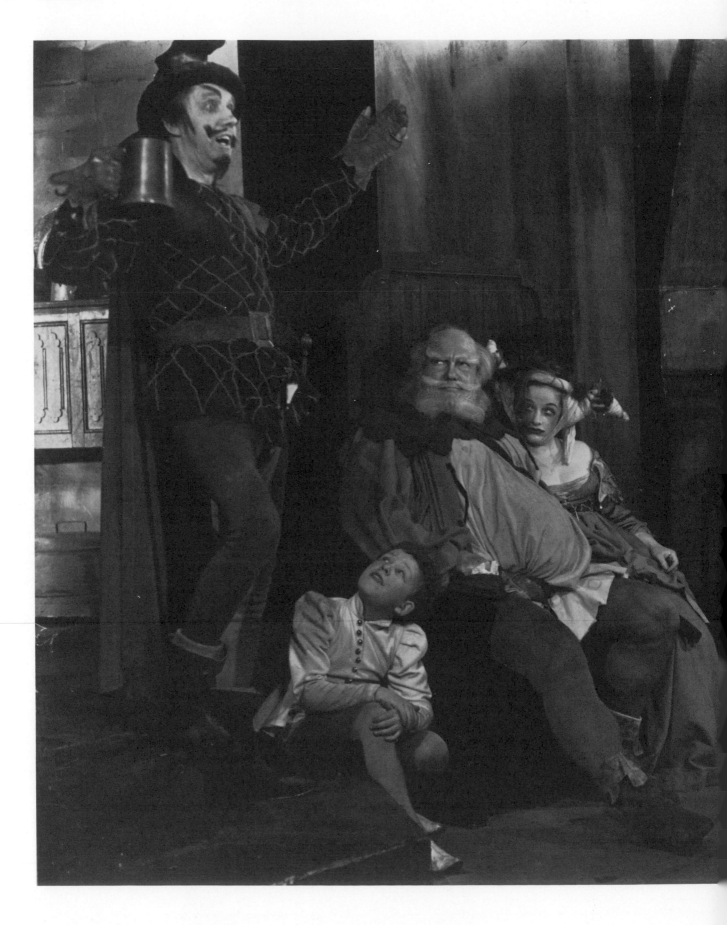

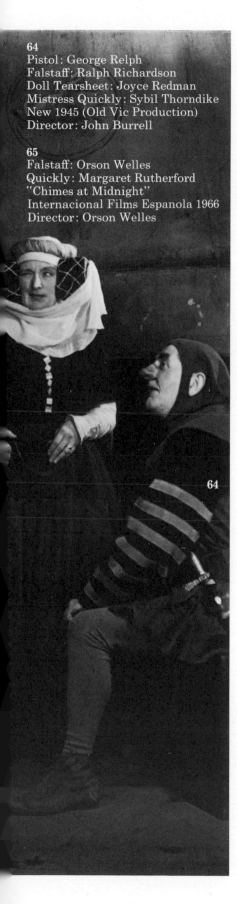

64
Pistol: George Relph
Falstaff: Ralph Richardson
Doll Tearsheet: Joyce Redman
Mistress Quickly: Sybil Thorndike
New 1945 (Old Vic Production)
Director: John Burrell

65
Falstaff: Orson Welles
Quickly: Margaret Rutherford
"Chimes at Midnight"
Internacional Films Espanola 1966
Director: Orson Welles

64

FALSTAFF:
I would 'twere bed-time, Hal, and all well.
PRINCE HAL:
Why, thou owest God a death. *Exit*
FALSTAFF:
'Tis not due yet – I would be loath to pay him before his day. What need I be so forward with him that calls not on me? Well, 'tis no matter, honour pricks me on. Yea, but how if honour prick me off when I come on, how then? Can honour set to a leg? No. Or an arm? No. Or take away the grief of a wound? No. Honour hath no skill in surgery then? No. What is honour? A word. What is in that word honour? What is that honour? Air. A trim reckoning! Who hath it? He that died a'Wednesday. Doth he feel it? No. Doth he hear it? No. 'Tis insensible, then? Yea, to the dead. But will it not live with the living? No. Why? Detraction will not suffer it. Therefore I'll none of it. Honour is a mere scutcheon – and so ends my catechism.

PART I ACT V SCENE I

65

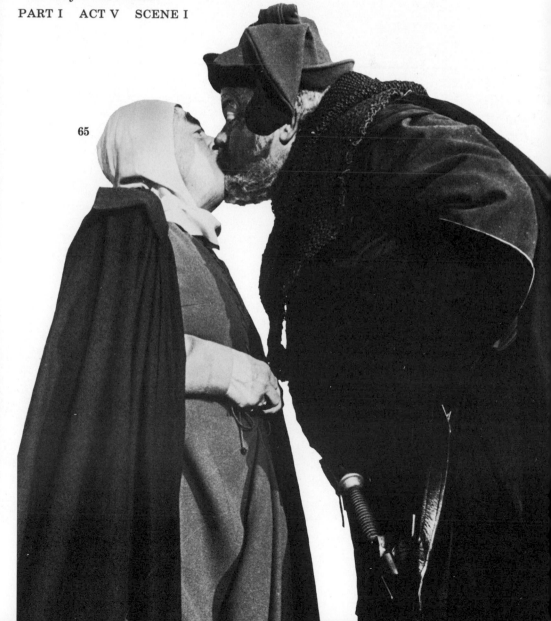

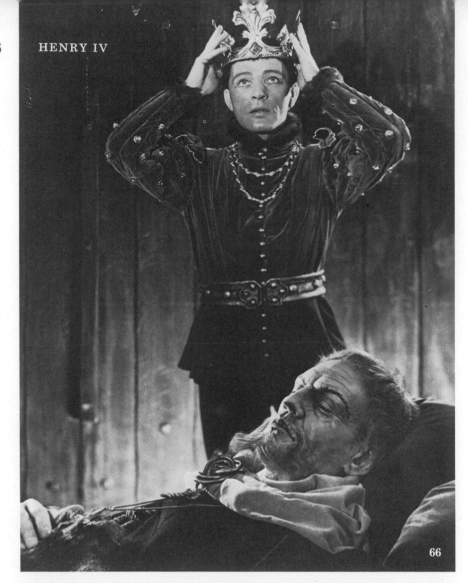

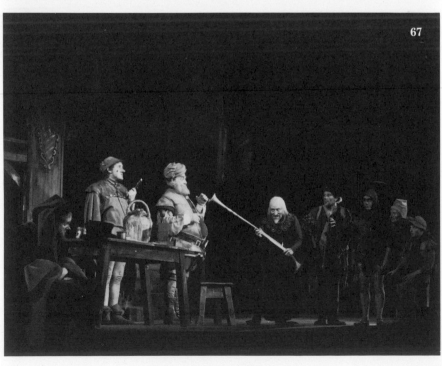

66
Prince Hal: Richard Burton
Henry IV: Harry Andrews
Stratford: 1951
Director: Michael Redgrave

67
Falstaff: Paul Rogers
Shallow: Paul Daneman
Old Vic 1955
Director: Douglas Seale

68
Falstaff: Brewster Mason
Lord Chief Justice: Griffith Jones
King Henry V: Alan Howard
Bardolph: Tim Wylton
Pistol: Richard Moore

69
Shallow: Sydney Bromley
Silence: Trevor Peacock

RSC Aldwych 1976
Director: Terry Hands

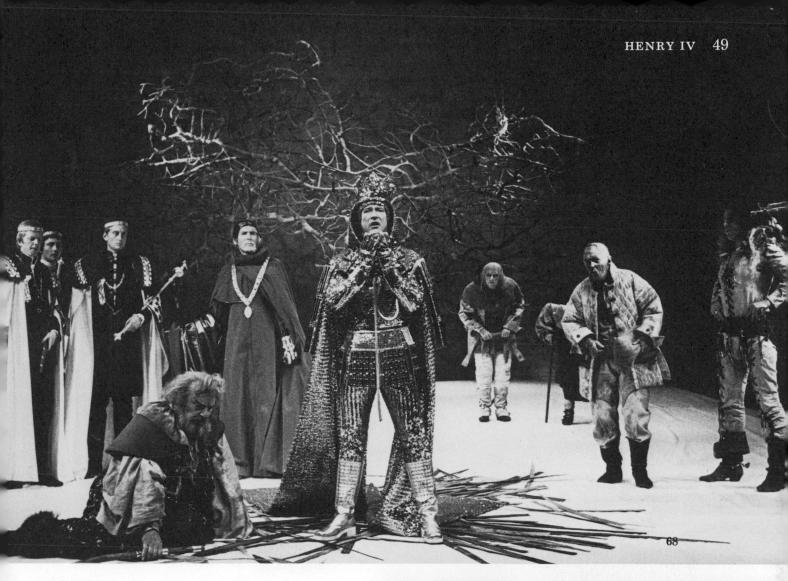

68

FALSTAFF:

My King, my Jove; I speak to thee, my heart.

KING HENRY V:

I know thee not, old man: fall to thy prayers:
How ill white hairs become a fool, and jester!
I have long dream'd of such a kind of man,
So surfeit-swell'd, so old, and so profane:
But being awake, I do despise my dream.

PART II ACT V SCENE V

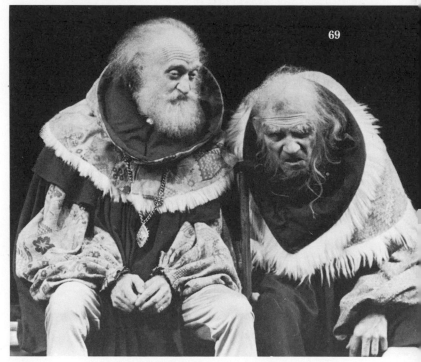

69

Henry V

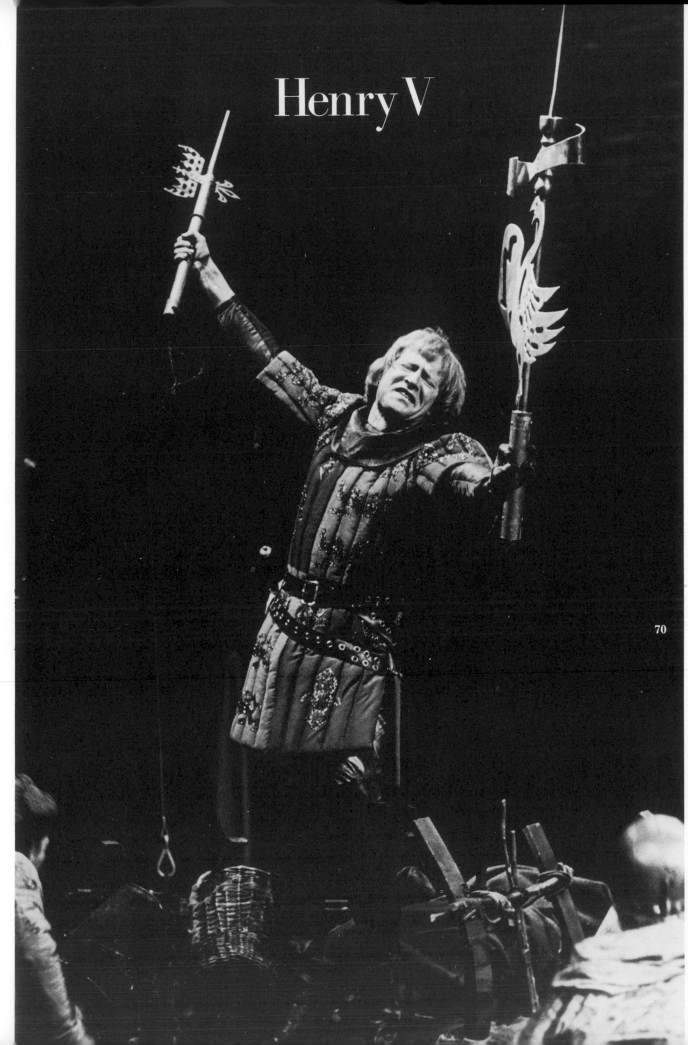

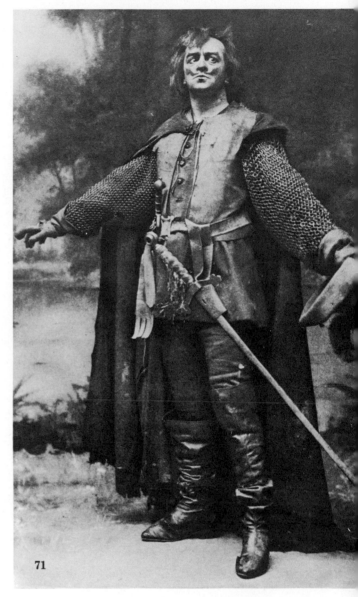

71

KING HENRY:

Once more unto the breach, dear friends, once more;
Or close the wall up with our English dead:
In peace, there's nothing so becomes a man,
As modest stillness, and humility:
But when the blast of war blows in our ears,
Then imitate the action of the tiger:
Stiffen the sinews, summon up the blood,
Disguise fair Nature with hard-favour'd rage:
Then lend the eye a terrible aspect:
Let it pry through the portage of the head,
Like the brass cannon: let the brow o'erwhelm it,
As fearfully, as doth a galled rock
O'erhang and jutty his confounded base,
Swill'd with the wild and wasteful ocean.
Now set the teeth, and stretch the nostril wide,
Hold hard the breath, and bend up every spirit
To his full height. On, on, you noblest English,
Whose blood is fet from fathers of war-proof:
Fathers, that like so many Alexanders,
Have in these parts from morn till even fought,
And sheath'd their swords, for lack of argument.
Dishonour not your mothers: now attest,
That those whom you call'd fathers, did beget you.
Be copy now to men of grosser blood,
And teach them how to war. And you good yeomen,
Whose limbs were made in England, show us here
The mettle of your pasture: let us swear,
That you are worth your breeding: which I doubt not:
For there is none of you so mean and base,
That hath not noble lustre in your eyes.
I see you stand like greyhounds in the slips,
Straining upon the start. The game's afoot:
Follow your spirit; and upon this charge,
Cry, God for Harry, England, and Saint George.

ACT III SCENE I

70
Henry V: Alan Howard
RSC Stratford 1975
Director: Terry Hands

71
Pistol: William Mollison
Lyceum 1900
Director: Lewis Waller

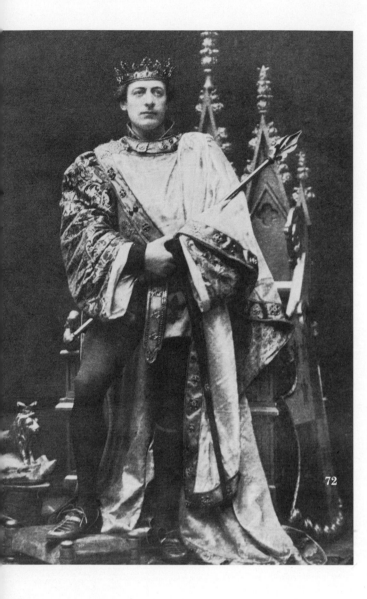

72

72 74
Henry V: Lewis Waller
Chorus: Lily Hanbury
Lyceum 1900
Director: Lewis Waller

73 75
Henry V: Laurence Olivier
Katharine: Renee Asherson
Alice: Ivy St. Helier
Two Cities/J. Arthur Rank Film 1944
Director: Laurence Olivier

KING HENRY:

This day is call'd the Feast of Crispian:
He that outlives this day, and comes safe home,
Will stand a tip-toe when this day is named,
And rouse him at the name of Crispian.
He that shall live this day, and see old age,
Will yearly on the Vigil feast his neighbours,
And say, to-morrow is Saint Crispian.
Then will he strip his sleeve, and show his scars:
Old men forget; yet all shall be forgot:
But he'll remember, with advantages,
What feats he did that day. Then shall our names,
Familiar in his mouth as household words,
Harry the King, Bedford and Exeter,
Warwick and Talbot, Salisbury and Gloucester,
Be in their flowing cups freshly remember'd.
This story shall the good man teach his son:
And Crispin Crispian shall ne'er go by,
From this day to the ending of the World,
But we in it shall be remembered:
We few, we happy few, we band of brothers:
For he to-day that sheds his blood with me,
Shall be my brother: be he ne'er so vile,
This day shall gentle his condition.
And gentlemen in England, now a-bed,
Shall think themselves accurs'd they were not here;
And hold their manhoods cheap, whiles any speaks,
That fought with us upon Saint Crispin's day.

ACT IV SCENE III

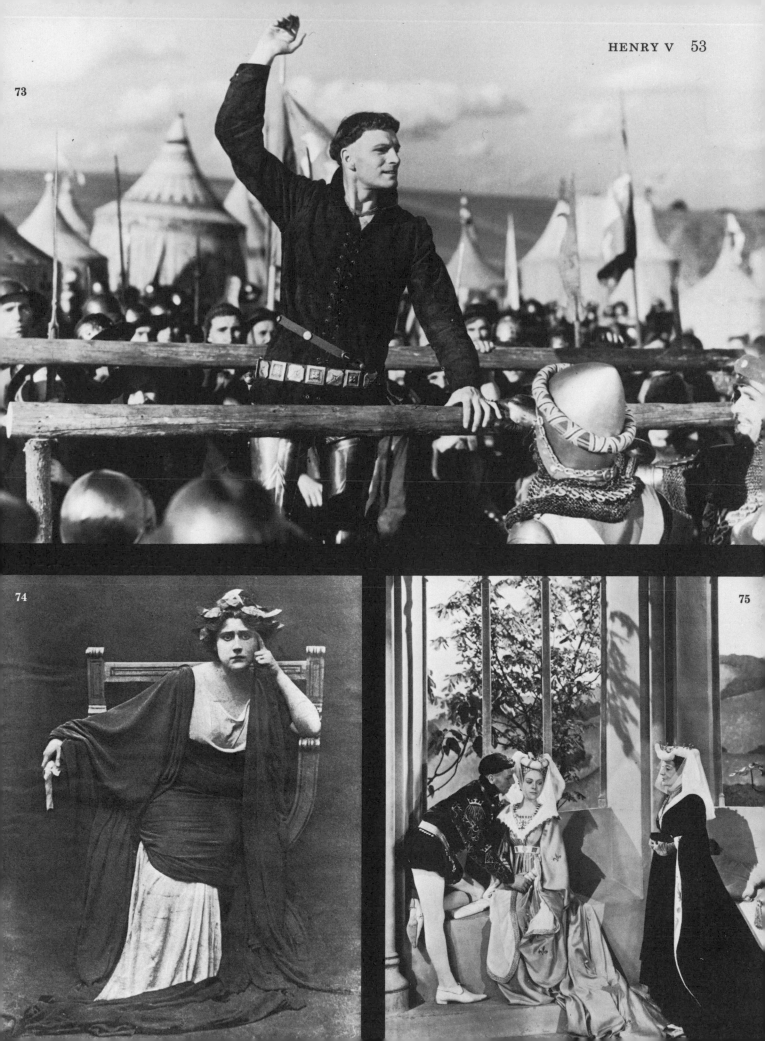

73

74

75

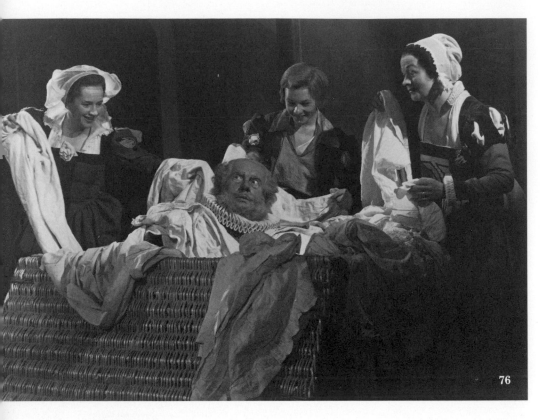

76

The Merry Wives of Windsor

FALSTAFF:

Have I liv'd to be carried in a basket like a barrow of butcher's offal? and to be thrown in the Thames? Well, if I be serv'd such another trick, I'll have my brains ta'en out and butter'd, and give them to a dog for a New-Year's gift. The rogues slighted me into the river with as little remorse, as they would have drown'd a blind bitch's puppies, fifteen i'th litter: and you may know by my size, that I have a kind of alacrity in sinking: if the bottom were as deep as hell, I should down. I had been drown'd, but that the shore was shelvy and shallow: a death that I abhor: for the water swells a man; and what a thing should I have been, when I had been swell'd? I should have been a mountain of mummy.

ACT III SCENE IV

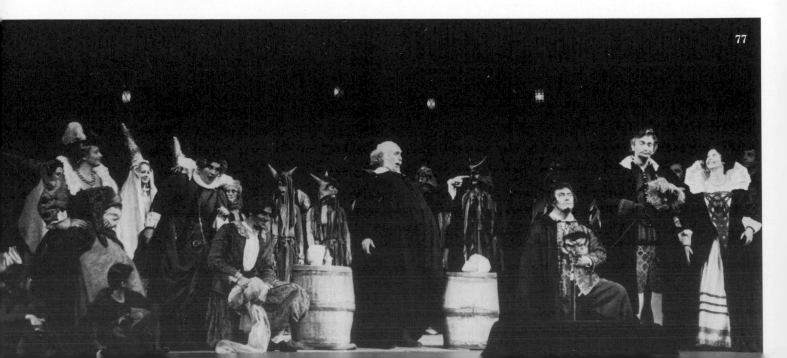

77

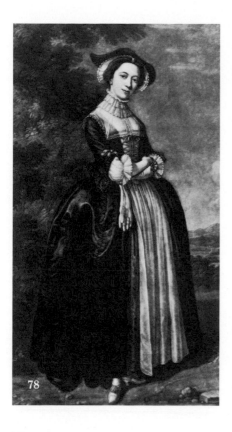

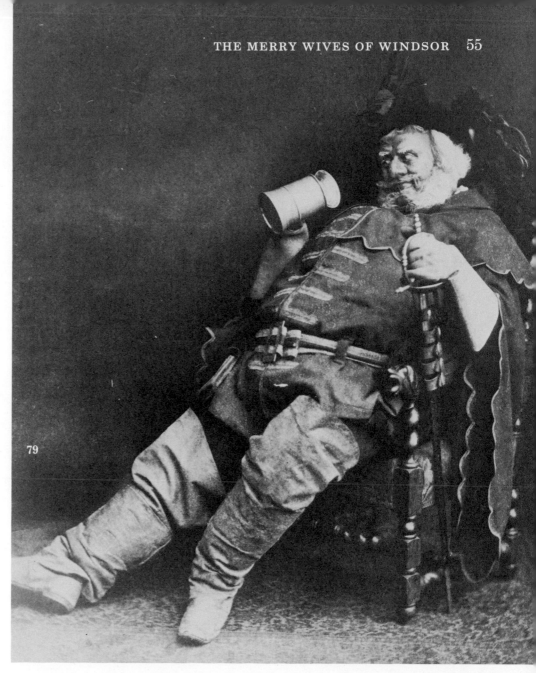

76
Mistress Page: Peggy Ashcroft
Falstaff: Roger Livesey
Robin: Brian Smith
Mistress Ford: Ursula Jeans
Old Vic 1951
Director: Hugh Hunt

77
Falstaff: Geraint Evans
Covent Garden Opera 1961
Director: Franco Zeffirelli

78
Mistress Ford: Margaret Woffington
1751

79
Falstaff: Herbert Beerbohm Tree
Haymarket 1889
Director: Herbert Beerbohm Tree

80
Rugby: John Southworth
Doctor Caius: Michael Denison
Shallow: Edward Atienza
Host: Patrick Wymark
Sir Hugh Evans: William Devlin
Master Page: Ralph Michael
Simple: Geoffrey Sasse
Slender: Geoffrey Bayldon
Stratford 1955
Director: Glen Byam Shaw

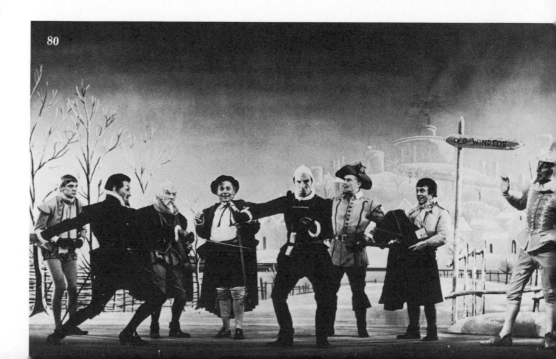

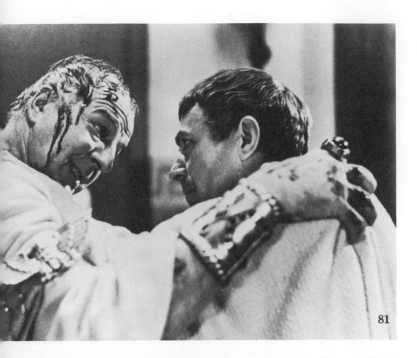

Julius Caesar

CASSIUS:

Why man, he doth bestride the narrow world
Like a Colossus, and we petty men
Walk under his huge legs, and peep about
To find ourselves dishonourable graves.
Men at some time, are masters of their fates.
The fault, dear Brutus, is not in our Stars,
But in ourselves, that we are underlings.
ACT I SCENE II

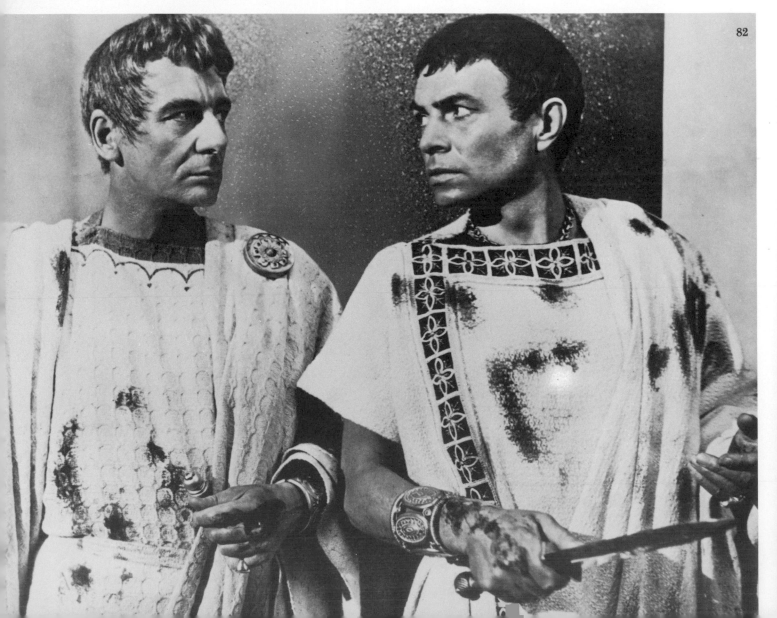

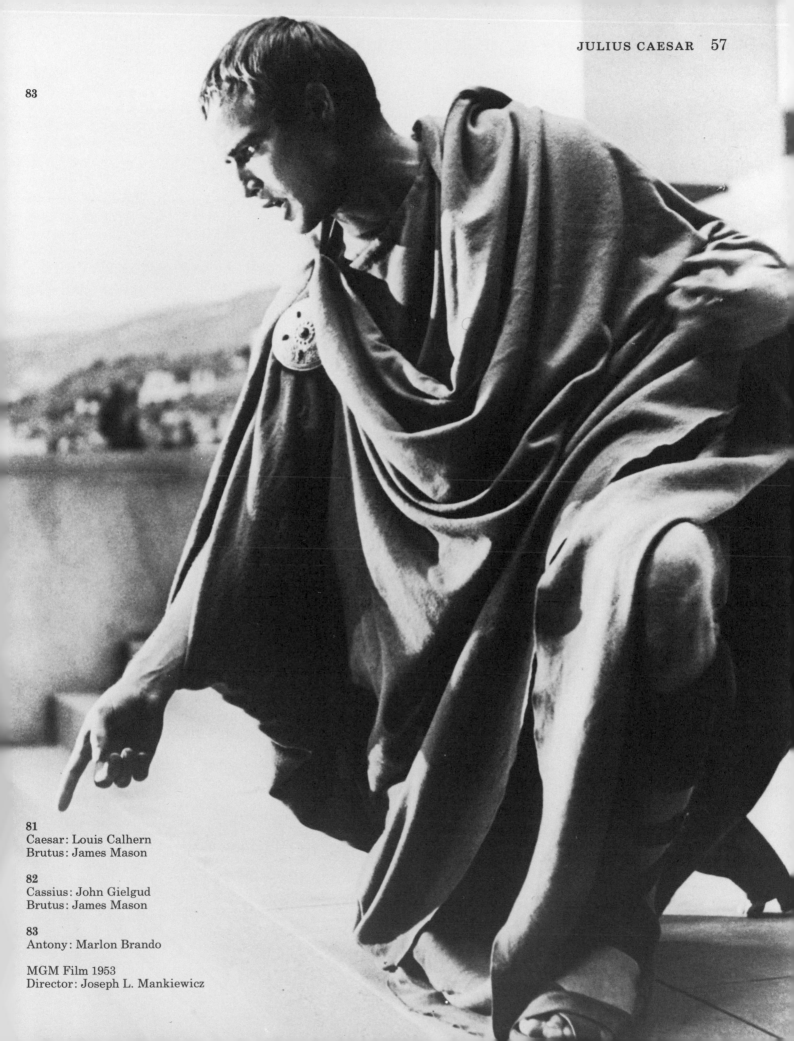

83

81
Caesar: Louis Calhern
Brutus: James Mason

82
Cassius: John Gielgud
Brutus: James Mason

83
Antony: Marlon Brando

MGM Film 1953
Director: Joseph L. Mankiewicz

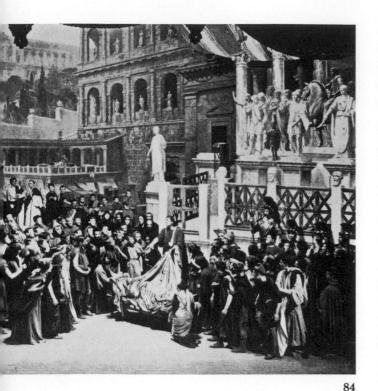

84

ANTONY:

Friends, Romans, countrymen, lend me your ears:
I come to bury Caesar, not to praise him.
The evil that men do, lives after them,
The good is oft interred with their bones,
So let it be with Caesar. The noble Brutus,
Hath told you Caesar was ambitious.
If it were so, it was a grievous fault,
And grievously hath Caesar answer'd it.
Here, under leave of Brutus, and the rest
(For Brutus is an honourable man,
So are they all; all honourable men)
Come I to speak in Caesar's funeral.
He was my friend, faithful, and just to me;
But Brutus says, he was ambitious,
And Brutus is an honourable man.
He hath brought many captives home to Rome,
Whose ransoms, did the general coffers fill:
Did this in Caesar seem ambitious?
When that the poor have cried, Caesar hath wept:
Ambition should be made of sterner stuff,
Yet Brutus says, he was ambitious:
And Brutus is an honourable man.
You all did see, that on the Lupercal,
I thrice presented him a kingly Crown,
Which he did thrice refuse. Was this ambition?
Yet Brutus says, he was ambitious:
And sure he is an honourable man.
I speak not to disprove what Brutus spoke,
But here I am, to speak what I do know.
You all did love him once, not without cause;
What cause withholds you then, to mourn for him?
O Judgement! thou art fled to brutish beasts,
And men have lost their reason. Bear with me,
My heart is in the coffin there with Caesar,
And I must pause, till it come back to me.

ACT III SCENE II

84
Antony: Herbert Beerbohm Tree
Her Majesty's 1898
Director: Herbert Beerbohm Tree

85
Antony: Henry Ainley
St. James's 1920
Director: Stanley Bell

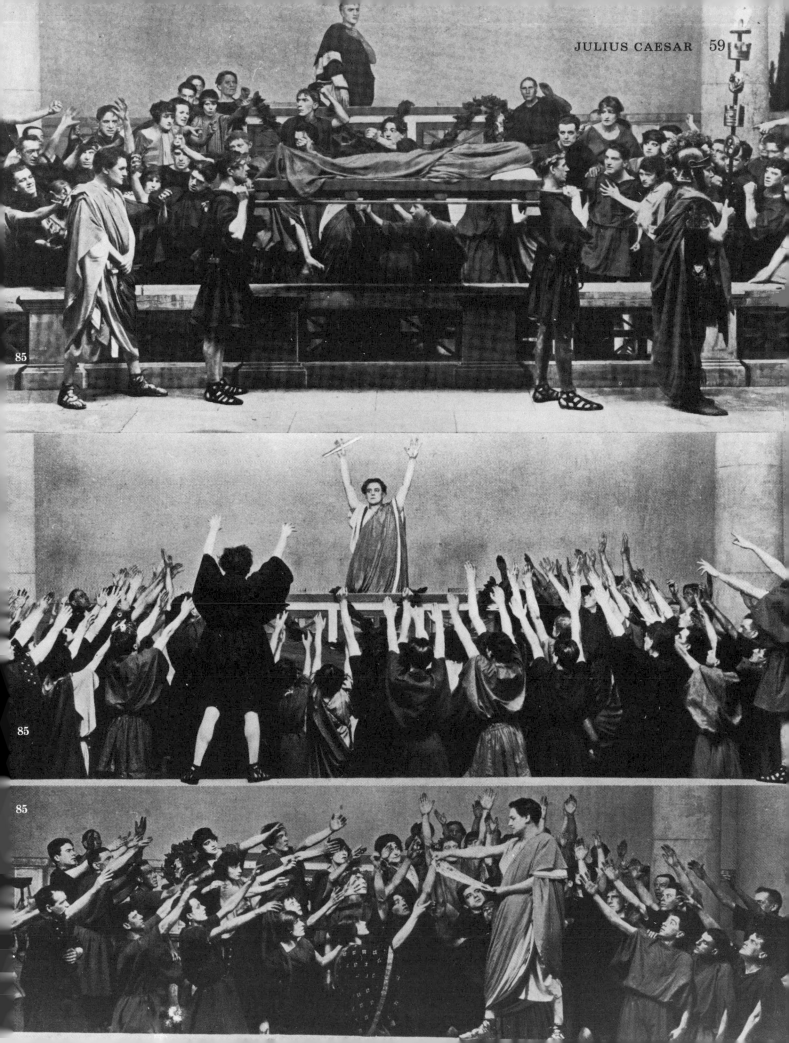

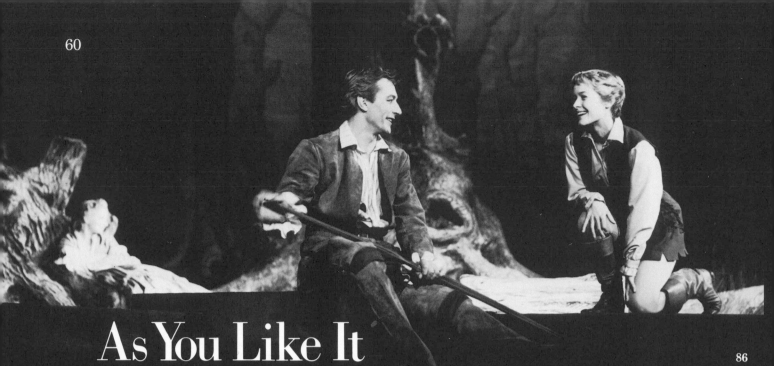

As You Like It

ROSALIND:
Come, woo me, woo me: for now I am in a holiday humour,
and like enough to consent: what would you say to me
now, and I were your very, very Rosalind?
ORLANDO:
I would kiss before I spoke.
ACT IV SCENE I

87

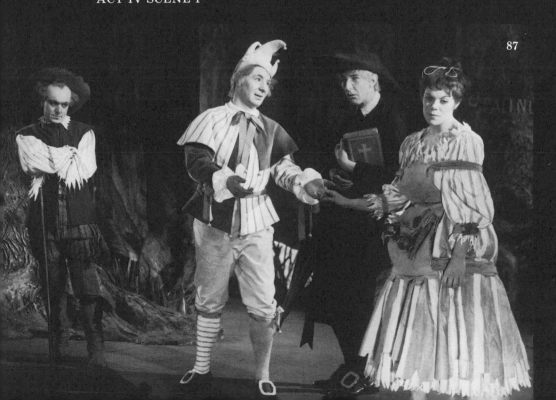

86 87
Orlando: John Neville
Rosalind: Virginia McKenna
Jaques: Eric Porter
Touchstone: Paul Rogers
Sir Oliver Martext: John Wood
Audrey: Rachel Roberts
Old Vic 1955
Director: Robert Helpman

JAQUES:

 All the world's a stage,
And all the men and women, merely Players;
They have their exits and their entrances,
And one man in his time plays many parts,
His Acts being seven ages. At first the infant,
Mewling, and puking in the nurse's arms:
Then, the whining school-boy with his satchel
And shining morning face, creeping like a snail
Unwillingly to school. And then the lover,
Sighing like furnace, with a woeful ballad
Made to his mistress' eyebrow. Then, a soldier,
Full of strange oaths, and bearded like the pard,
Jealous in honour, sudden, and quick in quarrel,
Seeking the bubble reputation
Even in the cannon's mouth: and then, the justice,
In fair round belly, with good capon lin'd,
With eyes severe, and beard of formal cut,
Full of wise saws, and modern instances,
And so he plays his part. The sixth age shifts
Into the lean and slipper'd pantaloon,
With spectacles on nose, and pouch on side,
His youthful hose well sav'd, a world too wide,
For his shrunk shank, and his big manly voice,
Turning again toward childish treble pipes,
And whistles in his sound. Last scene of all,
That ends this strange eventful history,
Is second childishness, and mere oblivion,
Sans teeth, sans eyes, sans taste, sans everything.
ACT II SCENE VII

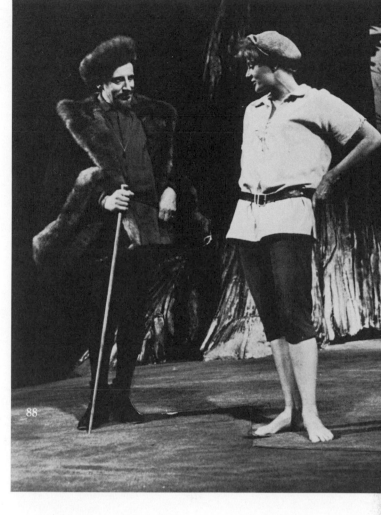

88
Jaques: Max Adrian
Rosalind: Vanessa Redgrave
RSC Stratford 1961
Director: Michael Elliot

89
Touchstone: Roy Kinnear
Corin: Terence Hardiman
RSC Stratford 1967
Director: David Jones

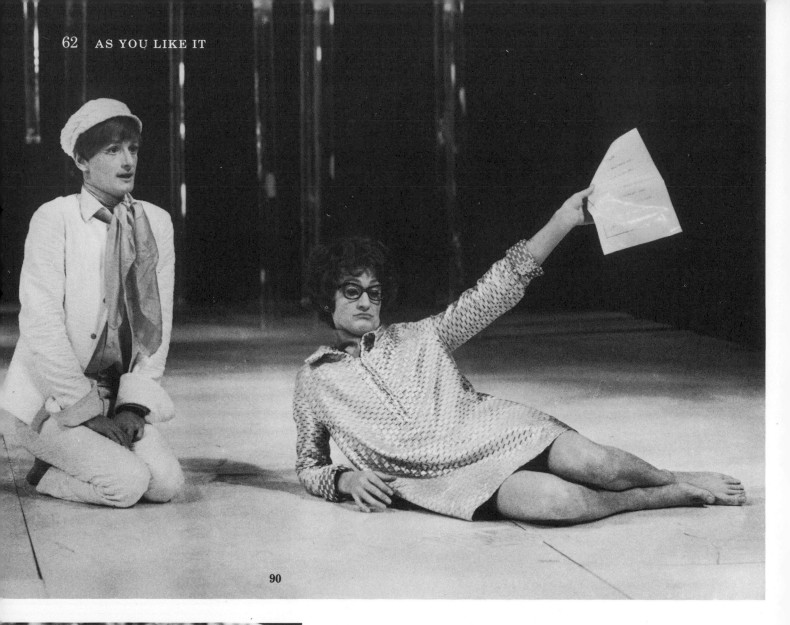

90

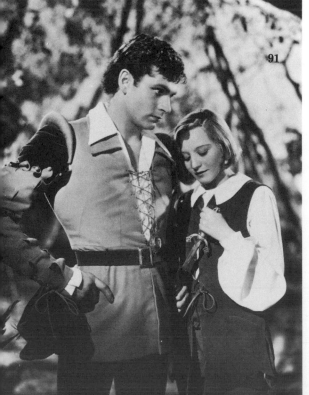

91

ROSALIND:
Now tell me how long you would have her after you have possessed her.

ORLANDO:
For ever and a day.

ROSALIND:
Say 'a day' without the 'ever'. No, no, Orlando, men are April when they woo, December when they wed; maids are May when they are maids, but the sky changes when they are wives. I will be more jealous of thee than a Barbary cock-pigeon over his hen, more clamorous than a parrot against rain, more new-fangled than an ape, more giddy in my desires than a monkey; I will weep for nothing, like Diana in the fountain, and I will do that when you are disposed to be merry; I will laugh like a hyena, and that when thou art inclined to sleep.

ACT IV SCENE I

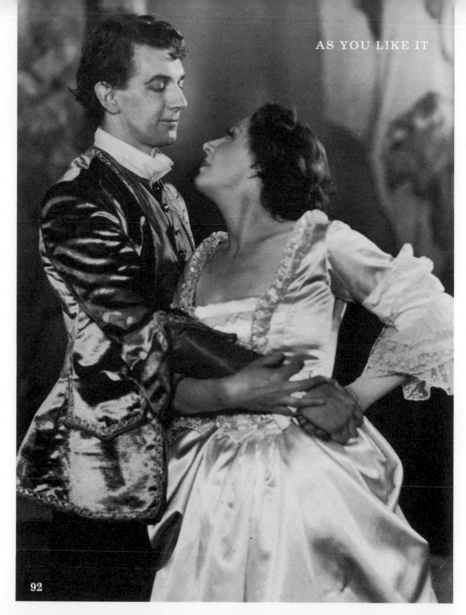

90
Rosalind: Ronald Pickup
Celia: Charles Kay
(all male production)
National 1967
Director: Clifford Williams

91
Orlando: Laurence Olivier
Rosalind: Elizabeth Bergner
Twentieth Century Fox Film 1936
Director: Paul Czinner

92 93
Rosalind: Edith Evans
Orlando: Michael Redgrave
Celia: Eileen Peel
Touchstone: Milton Rosmer
Old Vic 1938
Director: Esme Church

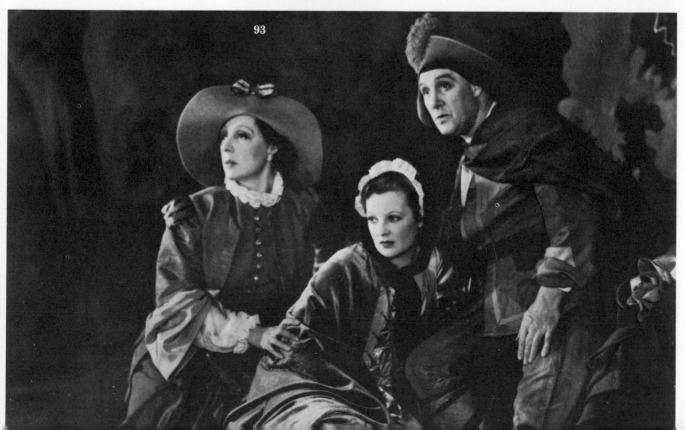

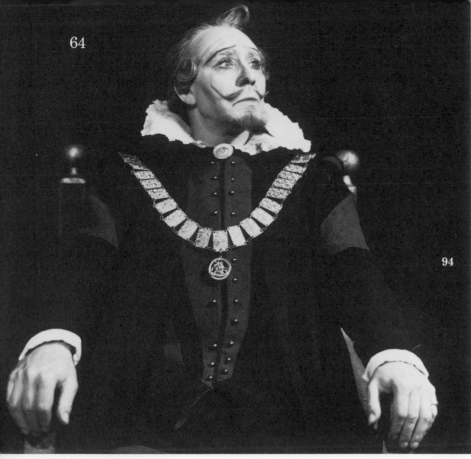

64

Twelfth Night
or What You Will

94
Malvolio: Donald Wolfit
Strand 1940
Director: Donald Wolfit

95
Viola: Lillah McCarthy
Olivia: Evelyn Millard
Savoy 1912
Director: Harley Granville-Barker

96
Feste: Robert Eddison
Prospect 1978
Director: Toby Robertson

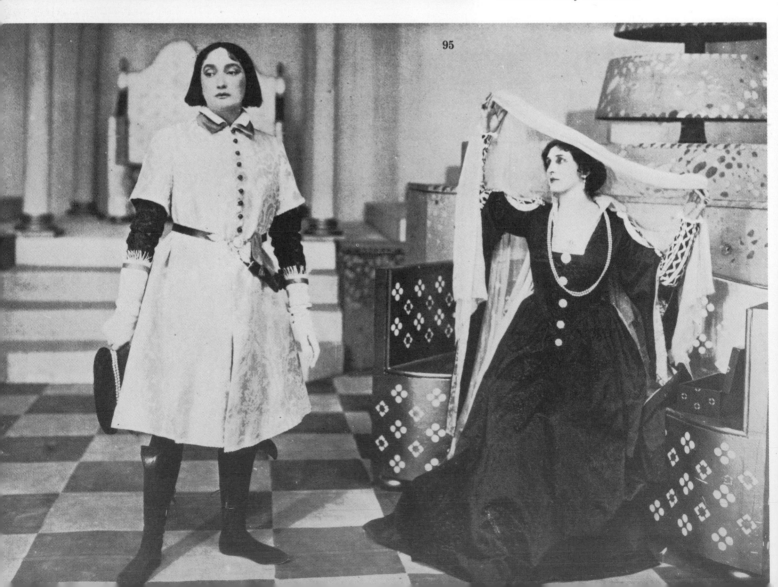

Song

FESTE:

O mistress mine where are you roaming?
O stay and hear, your true love's coming,
 That can sing both high and low.
Trip no further pretty sweeting;
Journeys end in lovers meeting,
 Every wise man's son doth know.

What is love, 'tis not hereafter,
Present mirth, hath present laughter:
 What's to come, is still unsure.
In delay there lies no plenty,
Then come kiss me sweet and twenty:
 Youth's a stuff will not endure.

ACT II SCENE III

96

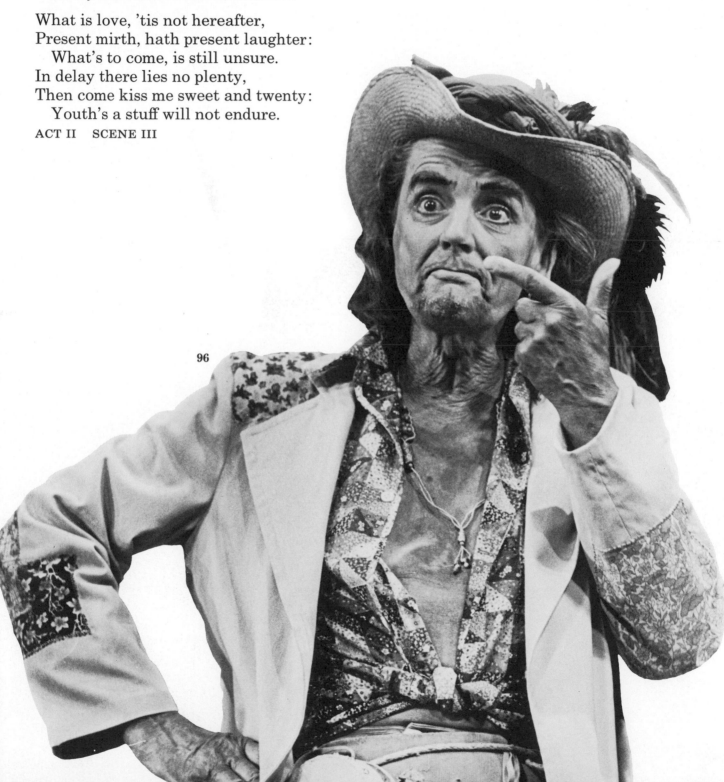

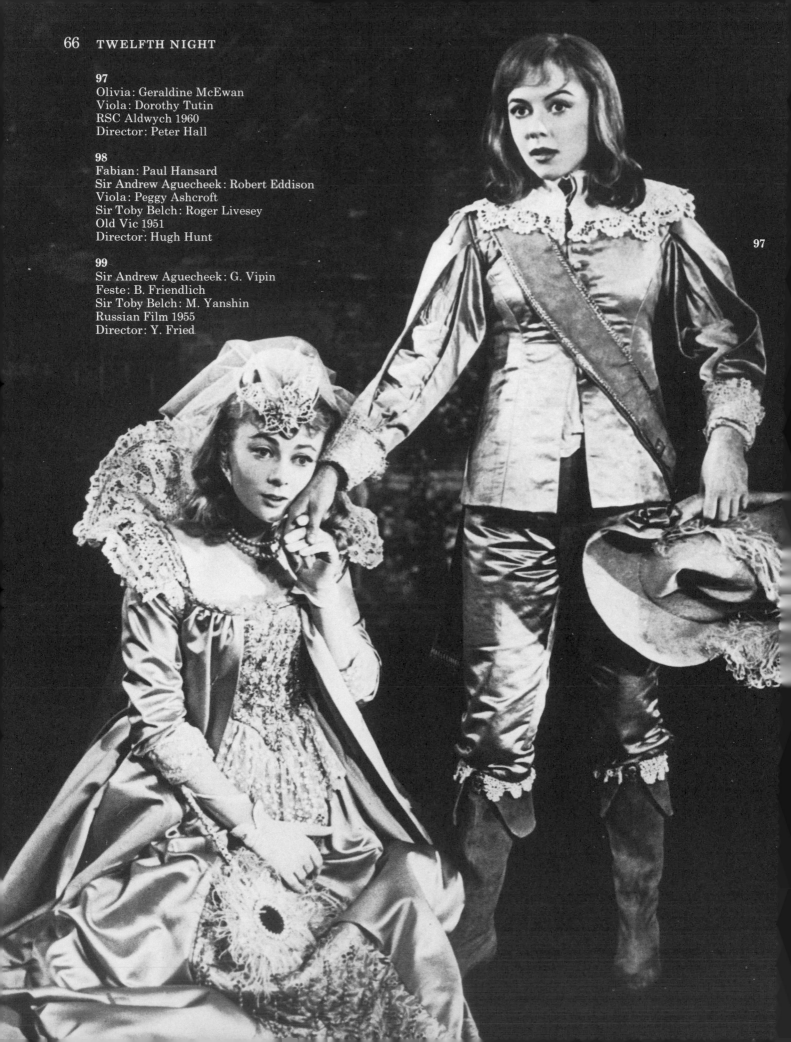

97
Olivia: Geraldine McEwan
Viola: Dorothy Tutin
RSC Aldwych 1960
Director: Peter Hall

98
Fabian: Paul Hansard
Sir Andrew Aguecheek: Robert Eddison
Viola: Peggy Ashcroft
Sir Toby Belch: Roger Livesey
Old Vic 1951
Director: Hugh Hunt

99
Sir Andrew Aguecheek: G. Vipin
Feste: B. Friendlich
Sir Toby Belch: M. Yanshin
Russian Film 1955
Director: Y. Fried

97

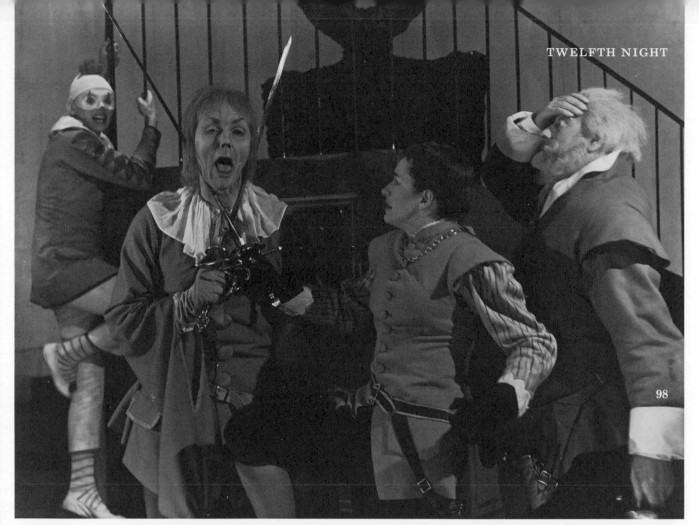

98

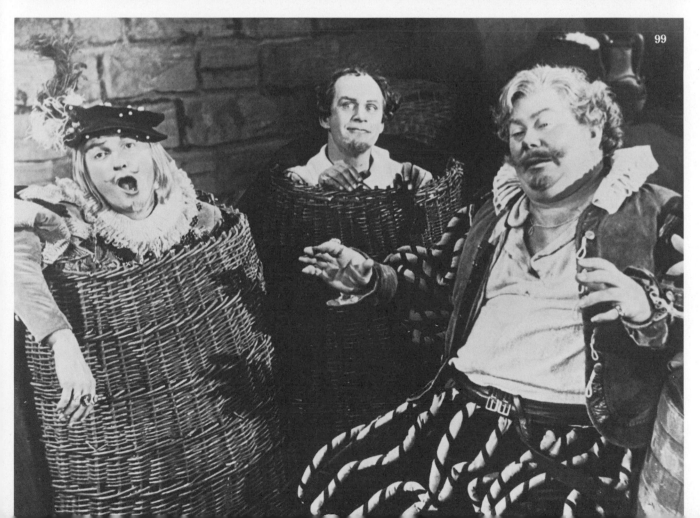

99

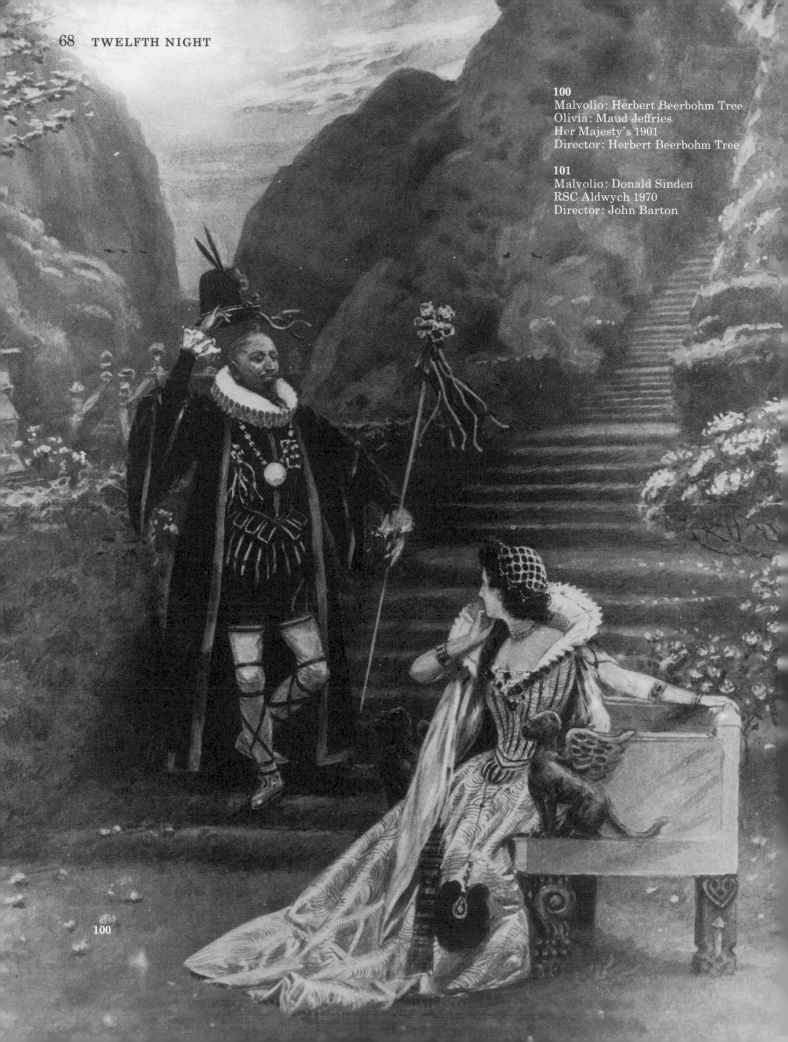

100
Malvolio: Herbert Beerbohm Tree
Olivia: Maud Jeffries
Her Majesty's 1901
Director: Herbert Beerbohm Tree

101
Malvolio: Donald Sinden
RSC Aldwych 1970
Director: John Barton

100

MALVOLIO:
Sweet Lady, ho, ho.

OLIVIA:
Smil'st thou? I sent for thee upon a sad occasion.

MALVOLIO:
Sad Lady, I could be sad: this does make some obstruction in the blood: this cross-gartering, but what of that? If it please the eye of one, it is with me as the very true sonnet is: Please one, and please all.

MARIA:
Why how dost thou man? what is the matter with thee?

MALVOLIO:
Not black in my mind, though yellow in my legs: it did come to his hands, and commands shall be executed. I think we do know the sweet Roman hand.

OLIVIA:
Wilt thou go to bed Malvolio?

MALVOLIO:
To bed? Ay sweet-heart, and I'll come to thee.

OLIVIA:
God comfort thee: why dost thou smile so, and kiss thy hand so oft?

MARIA:
How do you Malvolio?

MALVOLIO:
At your request: yes nightingales answer daws.

MARIA:
Why appear you with this ridiculous boldness before my Lady?

MALVOLIO:
Be not afraid of greatness: 'twas well writ.

OLIVIA:
What mean'st thou by that Malvolio?

MALVOLIO:
Some are born great.

OLIVIA:
Ha?

MALVOLIO:
Some achieve greatness.

OLIVIA:
What say'st thou?

MALVOLIO:
And some have greatness thrust upon them.

OLIVIA:
Heaven restore thee.

ACT III SCENE IV

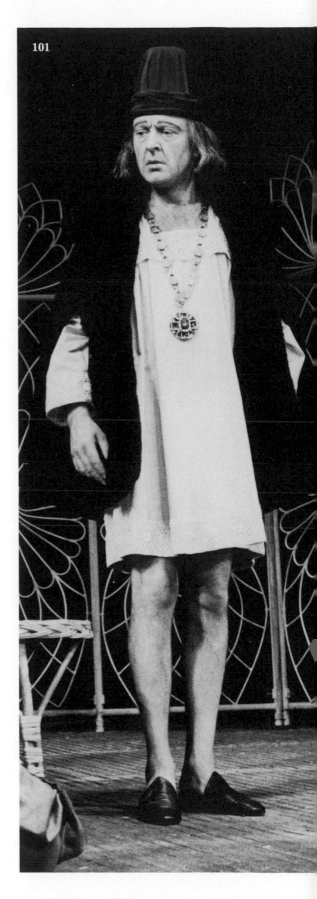

101

Hamlet

The time is out of joint: O cursed spite,
That ever I was born to set it right.

HAMLET:

To be, or not to be, that is the question:
Whether 'tis nobler in the mind to suffer
The slings and arrows of outrageous Fortune,
Or to take arms against a sea of troubles,
And by opposing end them: to die to sleep;
No more; and by a sleep, to say we end
The heart-ache, and the thousand natural shocks
That flesh is heir to? 'tis a consummation
Devoutly to be wish'd. To die to sleep,
To sleep, perchance to dream; ay, there's the rub,
For in that sleep of death, what dreams may come,
When we have shuffled off this mortal coil,
Must give us pause. There's the respect
That makes calamity of so long life:
For who would bear the whips and scorns of time,
The oppressor's wrong, the proud man's contumely,
The pangs of dispiz'd love, the Law's delay,
The insolence of office, and the spurns
That patient merit of the unworthy takes,
When he himself might his quietus make,
With a bare bodkin? who would fardels bear,
To grunt and sweat under a weary life,
But that the dread of something after death,
The undiscovered country, from whose bourn
No traveller returns, puzzles the will,
And makes us rather bear those ills we have,
Than fly to others that we know not of.
Thus conscience does make cowards of us all,
And thus the native hue of resolution
Is sicklied o'er, with the pale cast of thought,
And enterprises of great pith and moment,
With this regard their currents turn awry,
And lose the name of action.

ACT III SCENE I

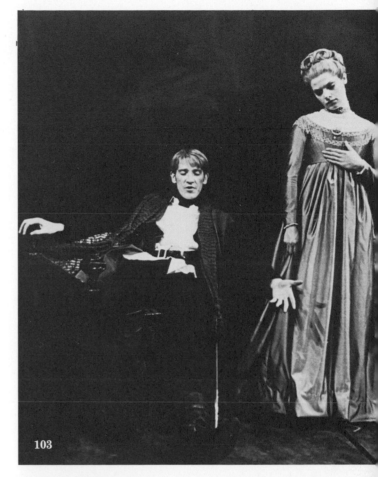

103

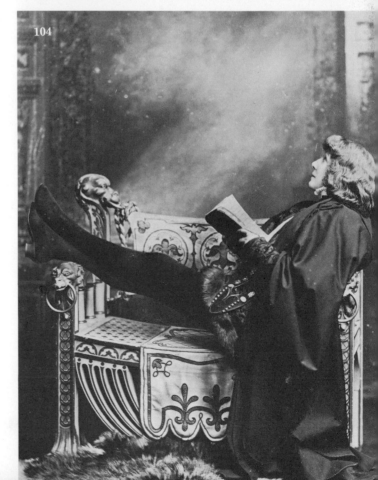

104

103
Hamlet: David Warner
Ophelia: Glenda Jackson
RSC Stratford 1965
Director: Peter Hall

102
Hamlet: John Barrymore
Haymarket 1925
Director: John Barrymore

104
Hamlet: Sarah Bernhardt
Adelphi 1899

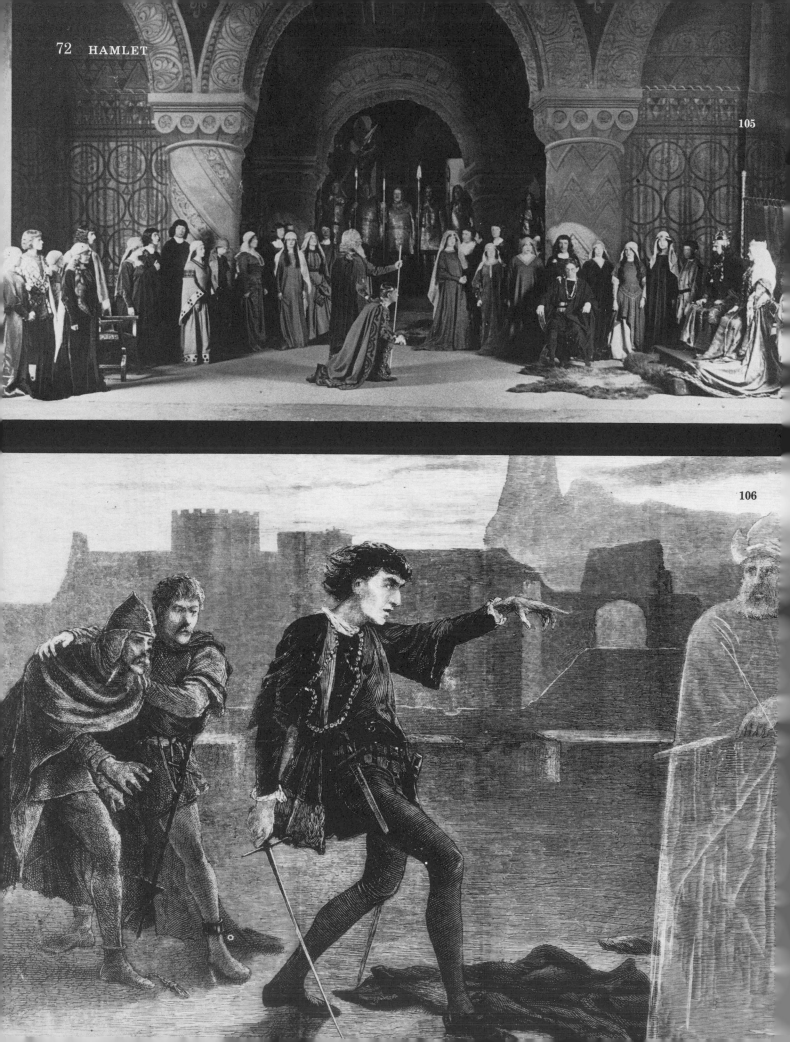

105

106

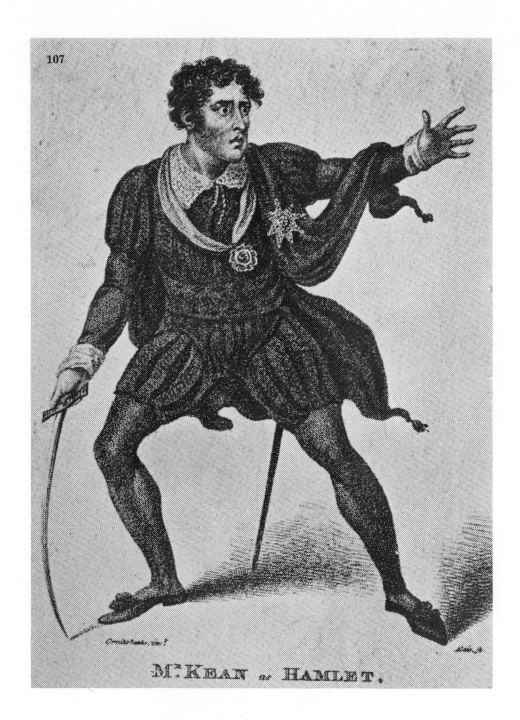

105
Hamlet: Johnston Forbes-Robertson
Drury Lane 1913 (farewell performance)
Director: Johnston Forbes-Robertson

106
Hamlet: Henry Irving
Lyceum
Director: Henry Irving

107
Hamlet: Edmund Kean (1787–1833)

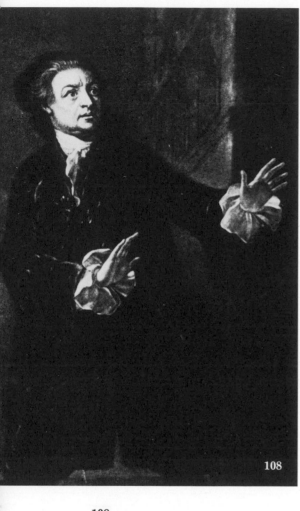

HAMLET:

I have of late, but wherefore I know not, lost all my mirth, forgone all custom of exercise; and indeed, it goes so heavily with my disposition; that this goodly frame the earth, seems to me a sterile promontory; this most excellent canopy the air, look you, this brave o'er-hanging firmament, this majestical roof, fretted with golden fire: why, it appears no other thing to me, than a foul and pestilent congregation of vapours. What a piece of work is a man! how noble in reason! how infinite in faculty! in form and moving how express and admirable! in action, how like an angel! in apprehension, how like a god! the beauty of the world, the paragon of animals; and yet to me, what is this quintessence of dust? man delights not me; no, nor woman neither; though by your smiling you seem to say so.

ACT II SCENE II

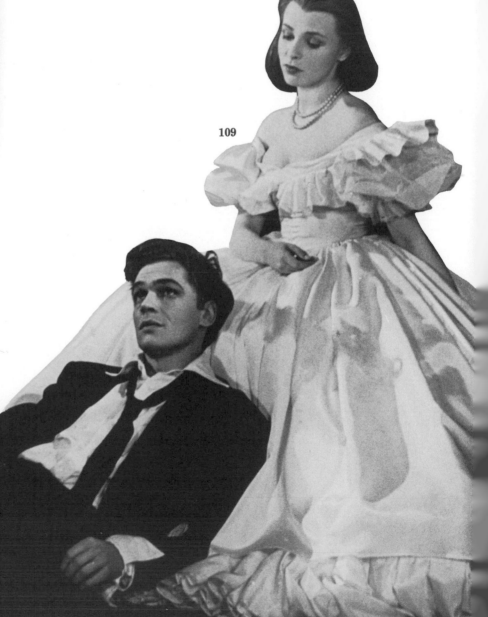

108
Hamlet: David Garrick
Drury Lane 1754

109
Hamlet: Paul Scofield
Ophelia: Claire Bloom
Stratford 1948
Director: Michael Benthall

110
Hamlet: John Gielgud
New 1934
Director: John Gielgud

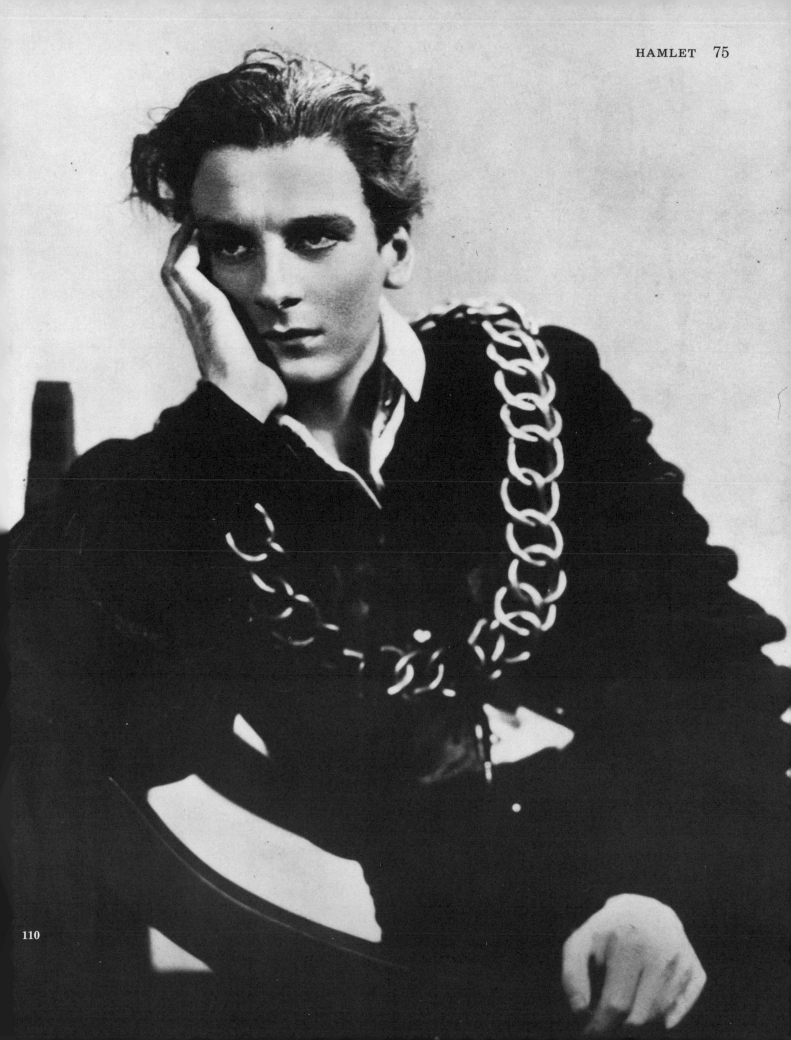

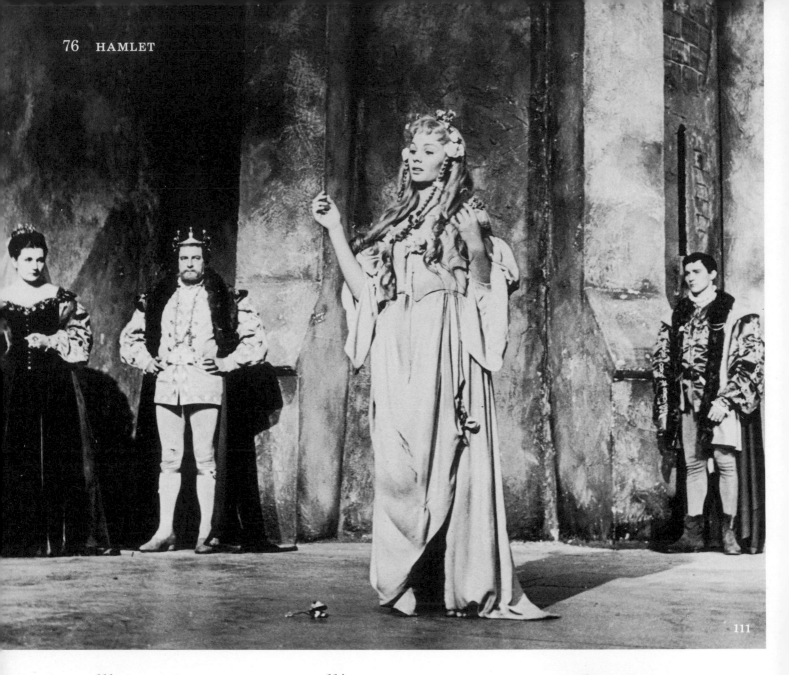

111

111
Gertrude: Eileen Herlie
Claudius: Basil Sydney
Ophelia: Jean Simmons
Laertes: Terence Morgan
J. Arthur Rank Film 1948
Director: Laurence Olivier

112
Ophelia: Lily Brayton
Adelphi 1905
Director: Johnston Forbes-Robertson

113
Polonius: Bromley Davenport
Ophelia: Muriel Hewitt
Kingsway 1952
Director: A. J. Ayliff

114
Ophelia: Anastasia Vertinskaya
Russian Film 1964
Director: Grigori Kozintsev

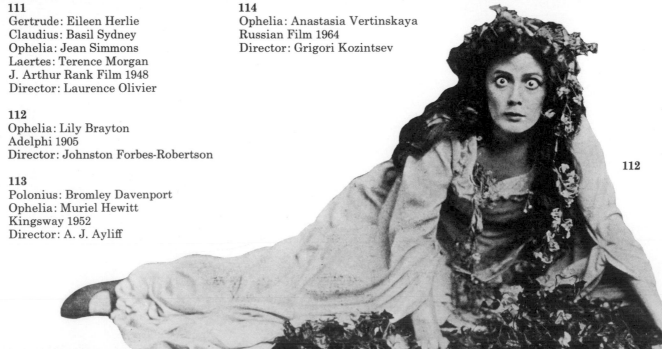

112

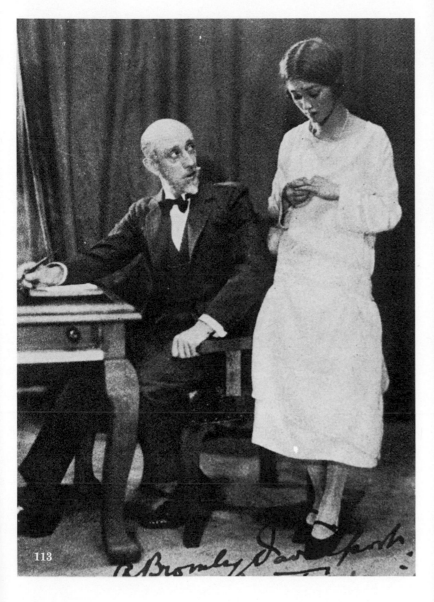

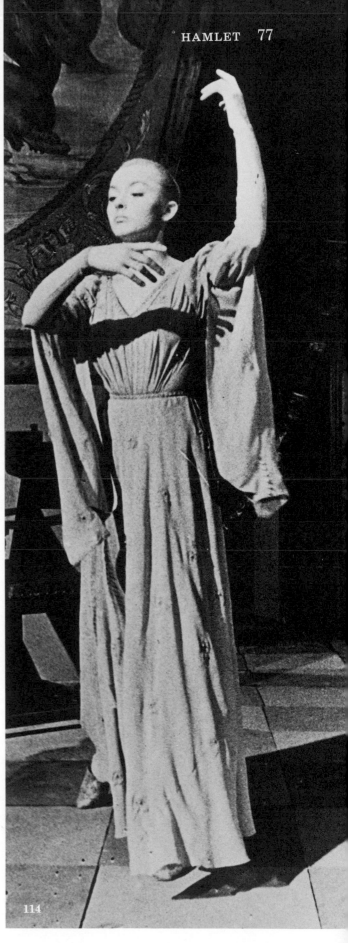

OPHELIA:

O what a noble mind is here o'erthrown!
The courtier's, soldier's, scholar's eye, tongue, sword,
Th' expectancy and rose of the fair State,
The glass of fashion, and the mould of form,
Th' observ'd of all observers, quite, quite down.
And I of ladies most deject and wretched,
That suck'd the honey of his music vows;
Now see that noble, and most sovereign reason,
Like sweet bells jangled out of tune, and harsh,
That unmatch'd form and feature of blown youth,
Blasted with ecstasy. O woe is me,
T' have seen what I have seen: see what I see.

ACT III SCENE I

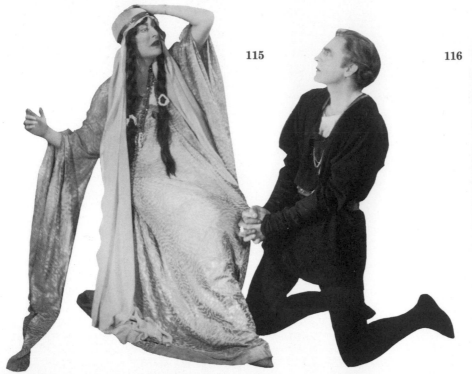

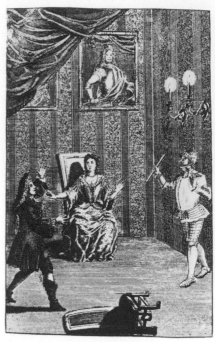

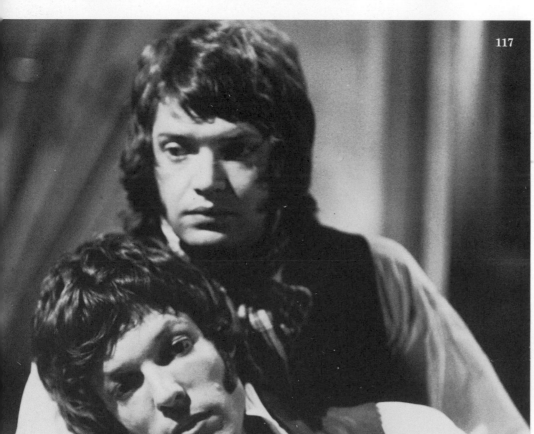

115
Gertrude: Constance Collier
Hamlet: John Barrymore
Haymarket 1925
Director: John Barrymore

116
Frontispiece of Rowe's Edition 1709

117
Hamlet: Richard Chamberlain
Horatio: Martin Shaw
ATV 1971
Director: Peter Wood

118
Hamlet: Michael Redgrave
New 1950 (Old Vic Production)
Director: Glen Byam Shaw

HAMLET:

Alas poor Yorick, I knew him Horatio, a fellow of infinite jest; of most excellent fancy, he hath borne me on his back a thousand times: and now how abhorred in my imagination it is, my gorge rises at it. Here hung those lips, that I have kiss'd I know not how oft. Where be your gibes now? your gambols? your songs? your flashes of merriment that were wont to set the table on a roar? Not one now to mock your own jeering? quite chop-fallen? Now get you to my Lady's chamber, and tell her, let her paint an inch thick, to this favour she must come. Make her laugh at that.

ACT V SCENE I

118

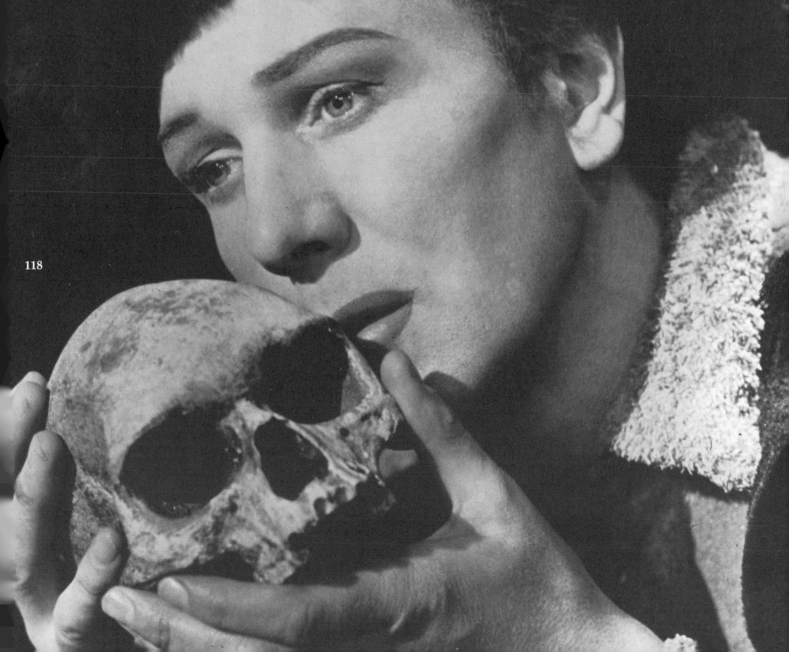

Troilus and Cressida

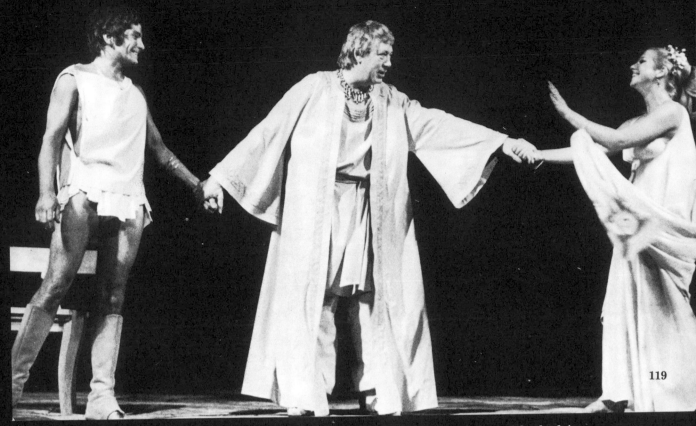

Lechery, lechery: still wars and lechery: nothing else holds fashion.

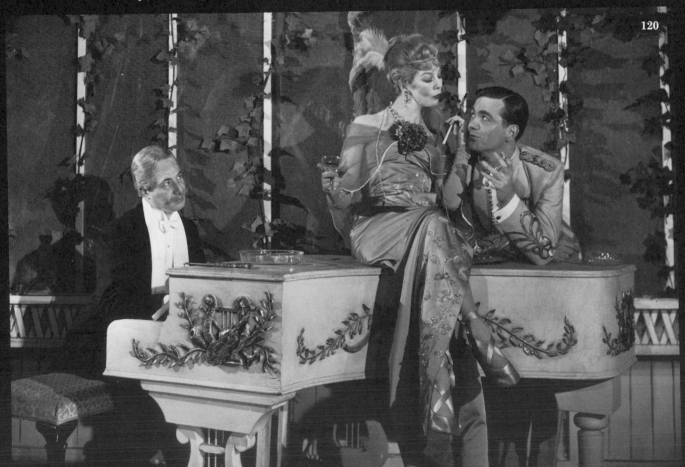

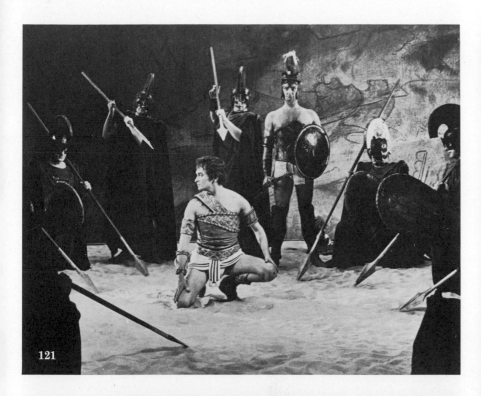

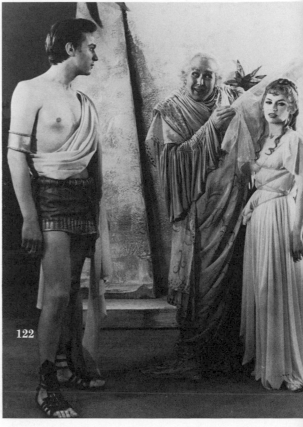

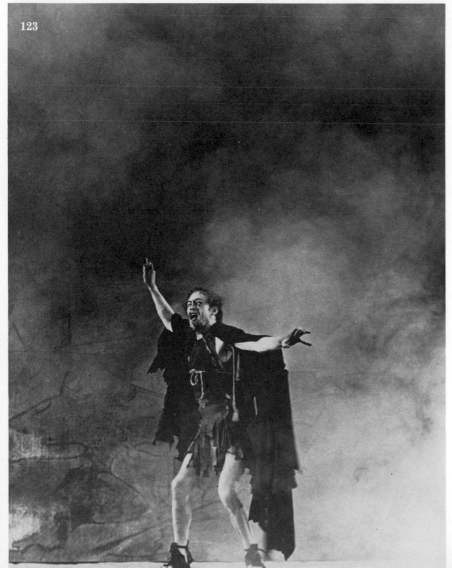

119
Troilus: Michael Williams
Pandarus: David Waller
Cressida: Helen Mirren
RSC Aldwych 1969
Director: John Barton

120
Pandarus: Paul Rogers
Helen: Wendy Hiller
Paris: Ronald Allen
Old Vic 1956
Director: Tyrone Guthrie

121
Hector: Derek Godfrey
Achilles: Patrick Allen
RSC Aldwych 1962
Director: Peter Hall

122
Troilus: Laurence Harvey
Pandarus: Anthony Quayle
Cressida: Muriel Pavlow
Stratford 1954
Director: Glen Byam Shaw

123
Thersites: Peter O'Toole
RSC Stratford 1960
Directors: Peter Hall John Barton

All's Well That Ends Well

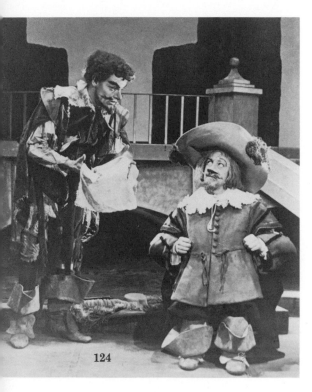

124

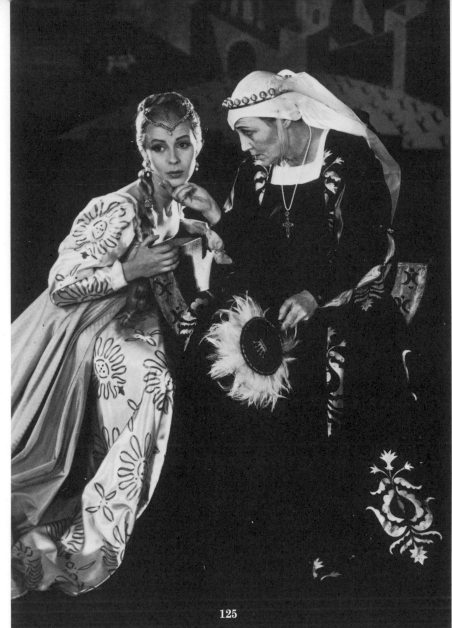

125

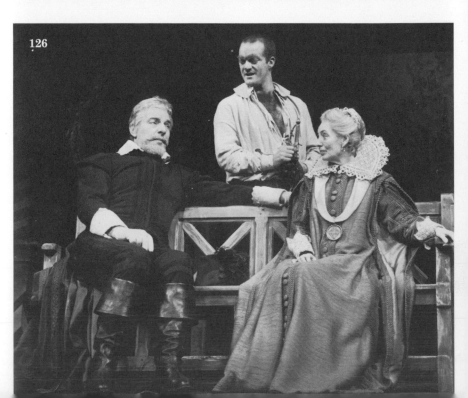

126

124
Parolles: Keith Michell
Lavache: Edward Atienza
Stratford 1955
Director: Noel Willman

125
Helena: Claire Bloom
Countess: Fay Compton
Old Vic 1953
Director: Michael Benthall

126
Lafeu: Brewster Mason
Lavache: Ian Hogg
Countess: Catherine Lacey
RSC Aldwych 1968
Director: John Barton

Othello

Speak of me, as I am. Nothing extenuate,
Nor set down aught in malice.
Then you must speak,
Of one that lov'd not wisely, but too well:
Of one, not easily jealous, but being wrought,
Perplex'd in the extreme.
ACT V SCENE II

127
Othello: Edmund Kean (1787–1833)

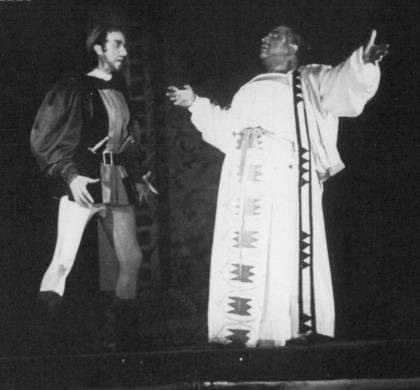

128
Othello: Frederick Valk
Iago: Bernard Miles
New 1942 (Old Vic Production)
Director: Julius Gellner

129
Otello: Jon Vickers
Iago: Peter Glossop
Covent Garden Opera 1977
Director: Peter Potter

130
Othello: Paul Robeson
Desdemona: Peggy Ashcroft
Savoy 1930
Director: Ellen Van Volkenburg

128

129

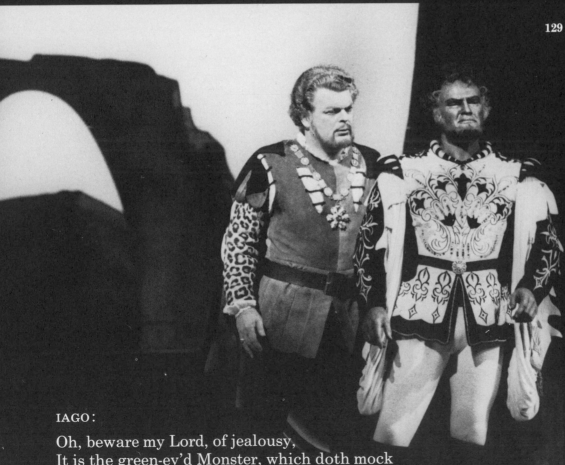

IAGO:

Oh, beware my Lord, of jealousy,
It is the green-ey'd Monster, which doth mock
The meat it feeds on.

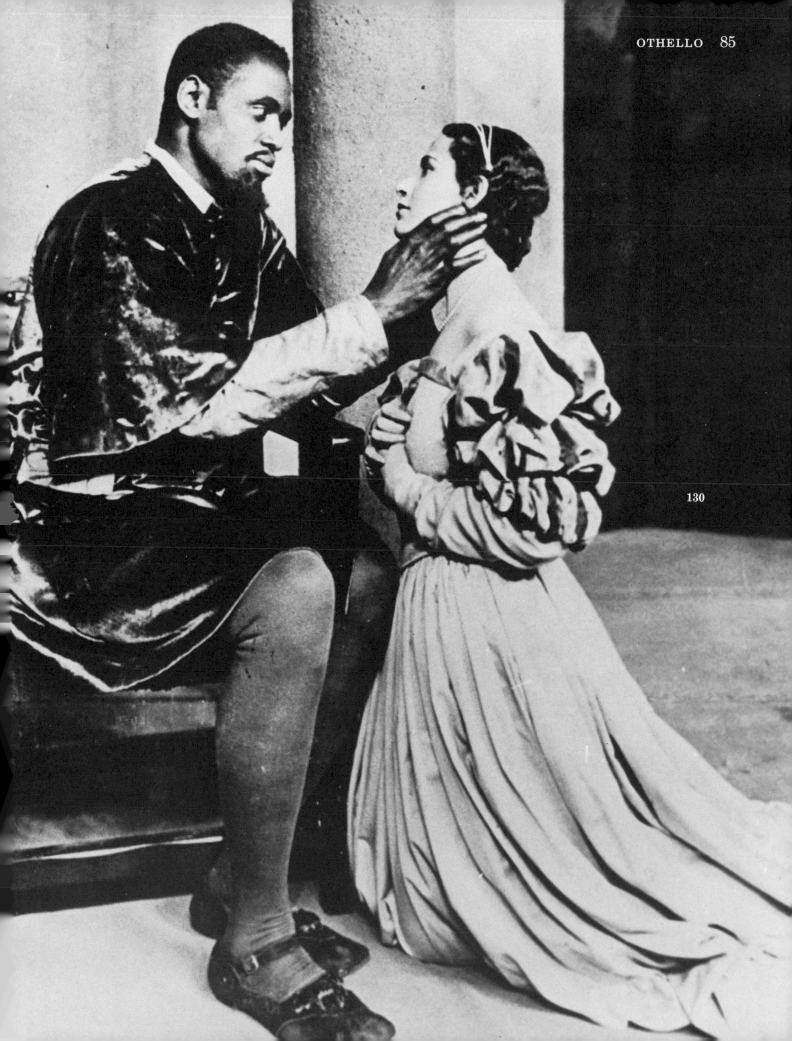

130

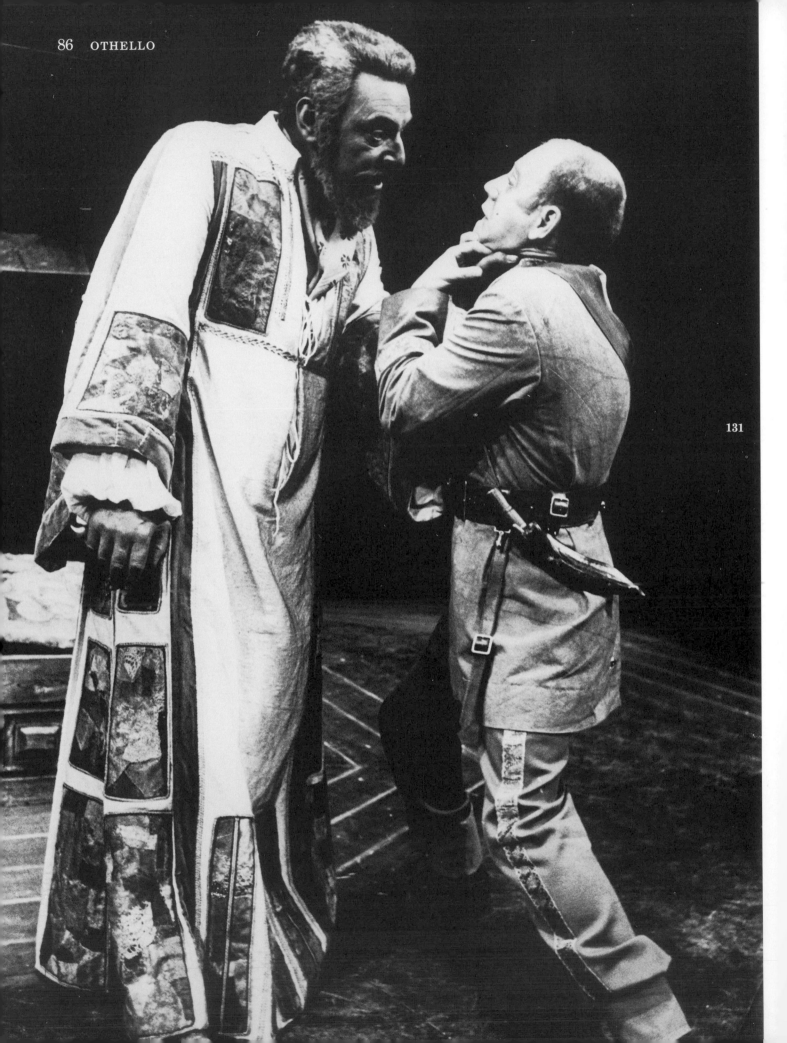

131

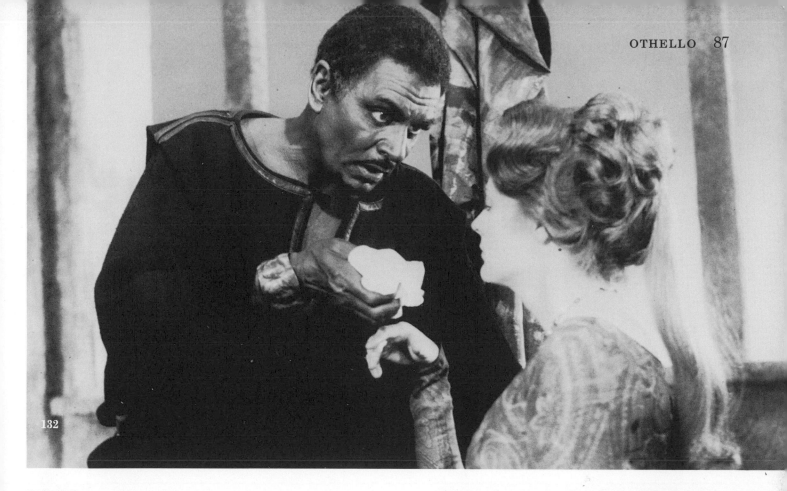

OTHELLO:

I had been happy, if the general camp,
Pioners and all, had tasted her sweet body,
So I had nothing known. Oh now, for ever
Farewell the tranquil mind; farewell content;
Farewell the plumed troops, and the big wars,
That makes ambition, virtue! Oh farewell,
Farewell the neighing steed, and the shrill trump,
The spirit-stirring drum, th' ear-piercing fife,
The royal banner, and all quality,
Pride, pomp, and circumstance of glorious War:
And O you mortal engines, whose rude throats
Th' immortal Jove's dread clamours, counterfeit,
Farewell: Othello's occupation's gone.
ACT III SCENE III

131
Othello: Brewster Mason
Iago: Emrys James
RSC Aldwych 1972
Director: John Barton

132
Othello: Laurence Olivier
Desdemona: Maggie Smith
National 1964 filmed 1966
Director stage: John Dexter
 film: Stuart Burge

133
Othello: Ira Aldridge
Royalty 1826

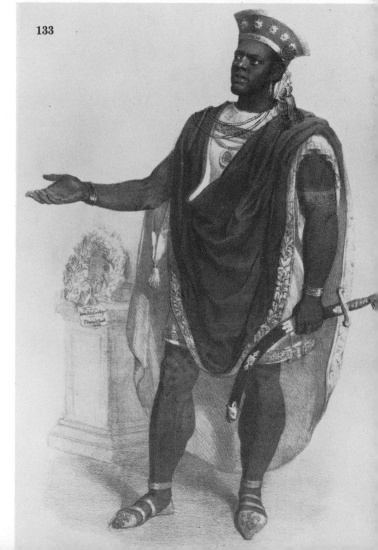

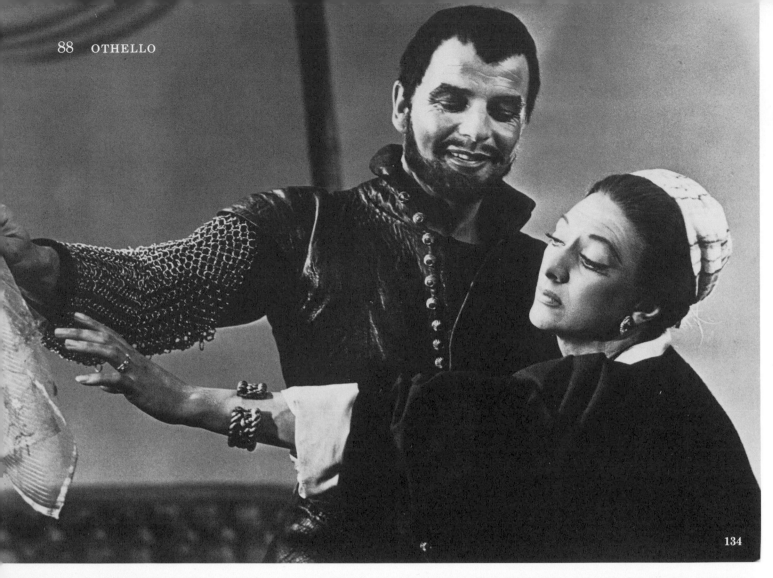

134

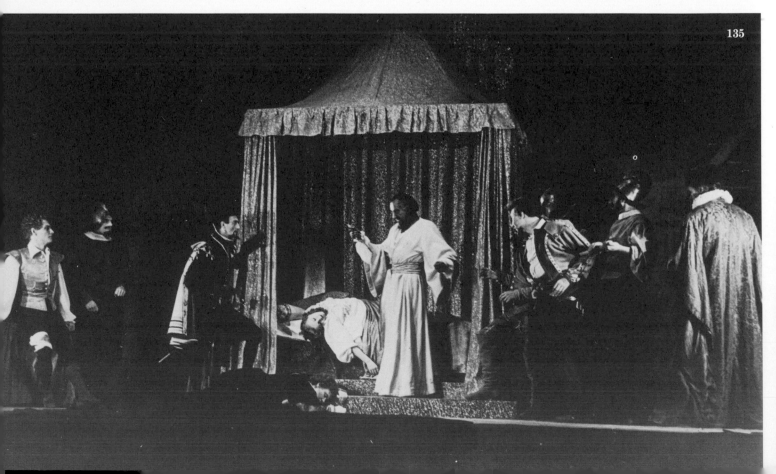

135

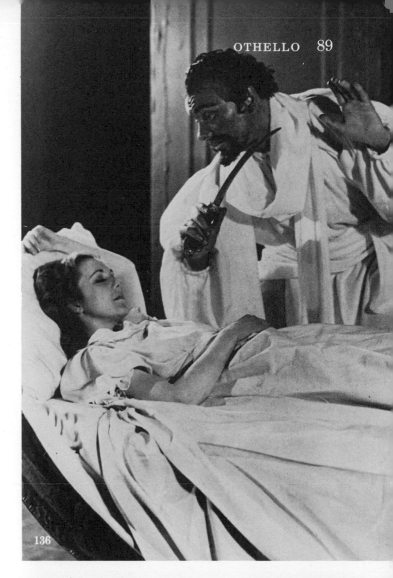

OTHELLO:

It is the cause, it is the cause, my soul,
Let me not name it to you, you chaste Stars,
It is the cause. Yet I'll not shed her blood,
Nor scar that whiter skin of hers, than snow,
And smooth as monumental alabaster:
Yet she must die, else she'll betray more men:
Put out the light, and then put out the light:
If I quench thee, thou flaming minister,
I can again thy former light restore,
Should I repent me. But once put out thy light,
Thou cunning'st pattern of excelling Nature,
I know not where is that Promethean heat
That can thy light re-lume.
When I have pluck'd thy rose,
I cannot give it vital growth again,
It needs must wither. I'll smell thee on the tree.
Oh balmy breath, that dost almost persuade
Justice to break her sword. One more, one more:
Be thus when thou art dead, and I will kill thee,
And love thee after. One more, and that's the last.
So sweet, was ne'er so fatal. I must weep,
But they are cruel tears: This sorrow's heavenly,
It strikes, where it doth love.

ACT V SCENE II

134
Iago: Emlyn Williams
Emilia: Diana Churchill
Stratford 1956
Director: Glen Byam Shaw

135
Othello: Godfrey Tearle
Desdemona: Diana Wynyard
Iago: Anthony Quayle
Stratford 1948
Director: Godfrey Tearle

136
Othello: Ralph Richardson
Desdemona: Curigwen Lewis
Old Vic 1937
Director: Tyrone Guthrie

137
Othello: Johnston Forbes-Robertson
Drury Lane 1913 (farewell performance)
Director: Johnston Forbes-Robertson

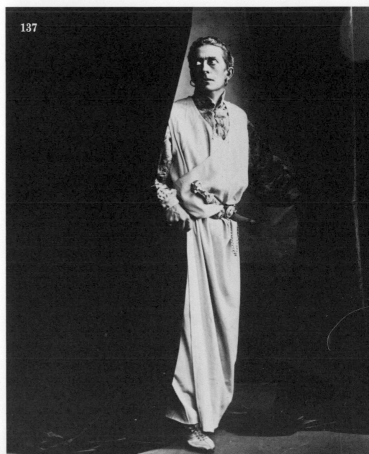

Measure For Measure

ISABELLA:

> But man, proud man,
> Dress'd in a little brief authority,
> Most ignorant of what he's most assur'd,
> His glassy essence like an angry ape
> Plays such fantastic tricks before high heaven,
> As make the angels weep: who with our spleens,
> Would all themselves laugh mortal.
>
> ACT II SCENE II

138

139

138
Angelo: Charles Laughton
Isabella: Flora Robson
Old Vic 1933
Director: Tyrone Guthrie

139
Angelo: Emlyn Williams
Isabella: Margaret Johnston
Stratford 1956
Director: Glen Byam Shaw

Timon of Athens

TIMON:

 I'll example you with thievery:
The sun's a thief, and with his great attraction
Robs the vast Sea. The Moon's an arrant thief,
And her pale fire, she snatches from the Sun.
The Sea's a thief, whose liquid surge, resolves
The Moon into salt tears. The Earth's a thief,
That feeds and breeds by a composture stolen
From gen'ral excrement: each thing's a thief.
ACT IV SCENE III

140
Timon: Ralph Richardson
Old Vic 1956
Director: Michael Benthall

King Lear

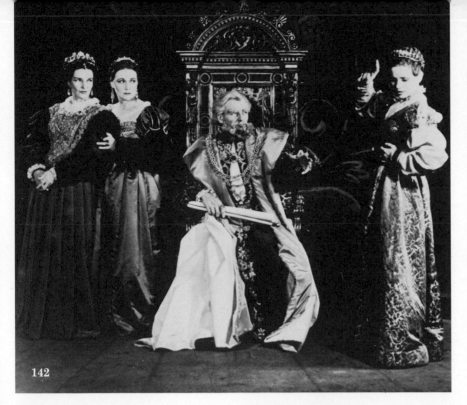

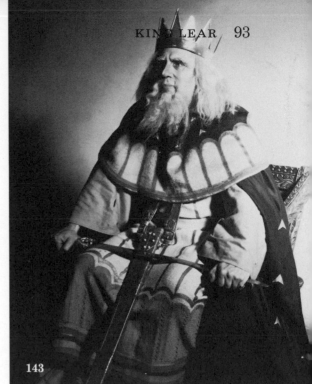

141
Lear: Eric Porter
RSC Stratford 1968
Director: Trevor Nunn

142
Goneril: Cathleen Nesbitt
Regan: Fay Compton
Lear: John Gielgud
Cordelia: Jessica Tandy
Old Vic 1940
Directors: John Gielgud,
Tyrone Guthrie, Lewis Casson
Consultant: Harley Granville-Barker

143
Lear: Donald Wolfit
St. James's 1942
Director: Donald Wolfit

144
Lear: Randle Ayrton
Cordelia: Rosalind Iden
Stratford 1936
Director: Theodore Komisarjevsky

145
Lear: Charles Laughton
Cordelia: Stephanie Bidmead
Stratford 1959
Director: Glen Byam Shaw

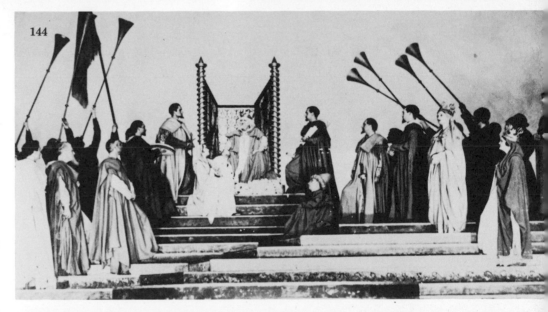

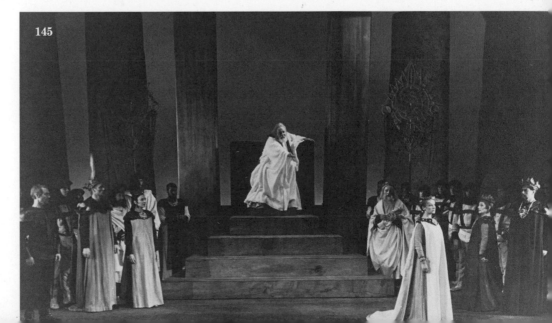

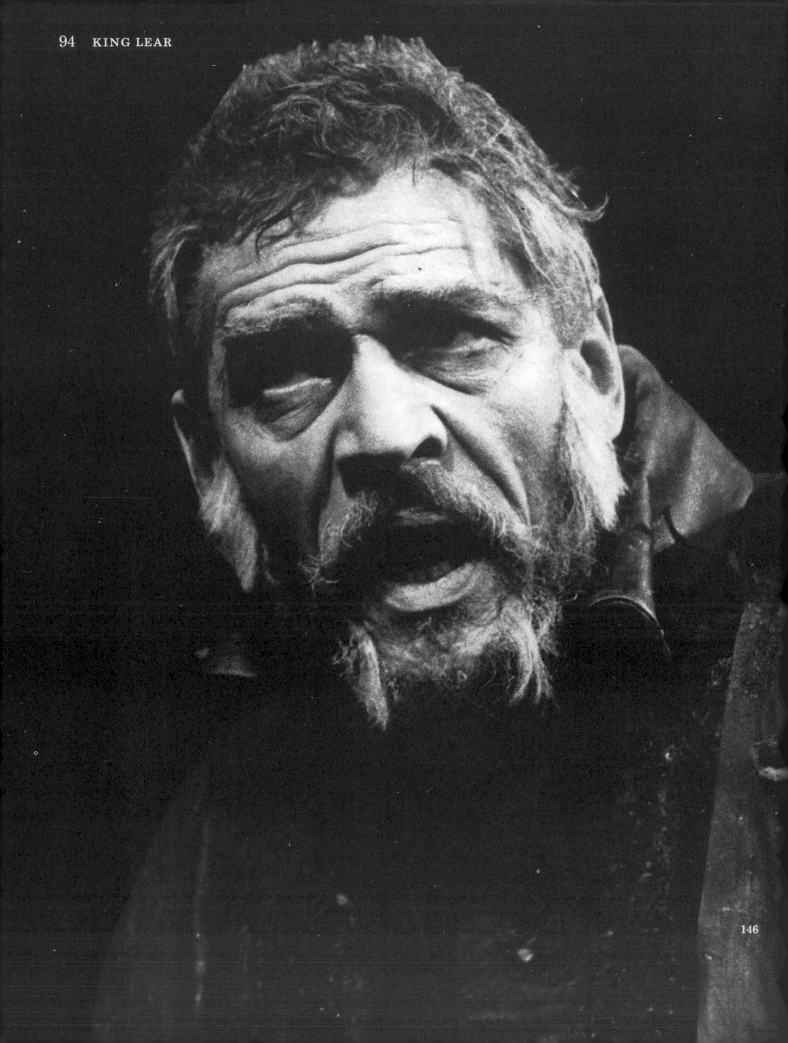

146

LEAR:

O reason not the need: our basest beggars
Are in the poorest thing superfluous,
Allow not Nature, more than Nature needs:
Man's life is cheap as beast's. Thou art a Lady;
If only to go warm were gorgeous,
Why Nature needs not what thou gorgeous wear'st,
Which scarcely keeps thee warm, but for true need,
You Heavens, give me that patience, patience I need.
You see me here, you Gods, a poor old man,
As full of grief as age, wretched in both.
If it be you that stirs these daughters' hearts
Against their father, fool me not so much,
To bear it tamely: touch me with noble anger,
And let not women's weapons, water-drops,
Stain my man's cheeks. No you unnatural hags,
I will have such revenges on you both,
That all the world shall—I will do such things.
What they are yet, I know not, but they shall be
The terrors of the earth! You think I'll weep,
No, I'll not weep. I have full cause of weeping.
 Storm and Tempest
But this heart shall break into a hundred thousand flaws
Or ere I'll weep: O fool, I shall go mad.
ACT II SCENE IV

146
Lear: Paul Scofield
RSC Stratford 1962
Director: Peter Brook

147
Lear: Donald Sinden
Gloucester: Tony Church
RSC Aldwych 1977
Director: Trevor Nunn

147

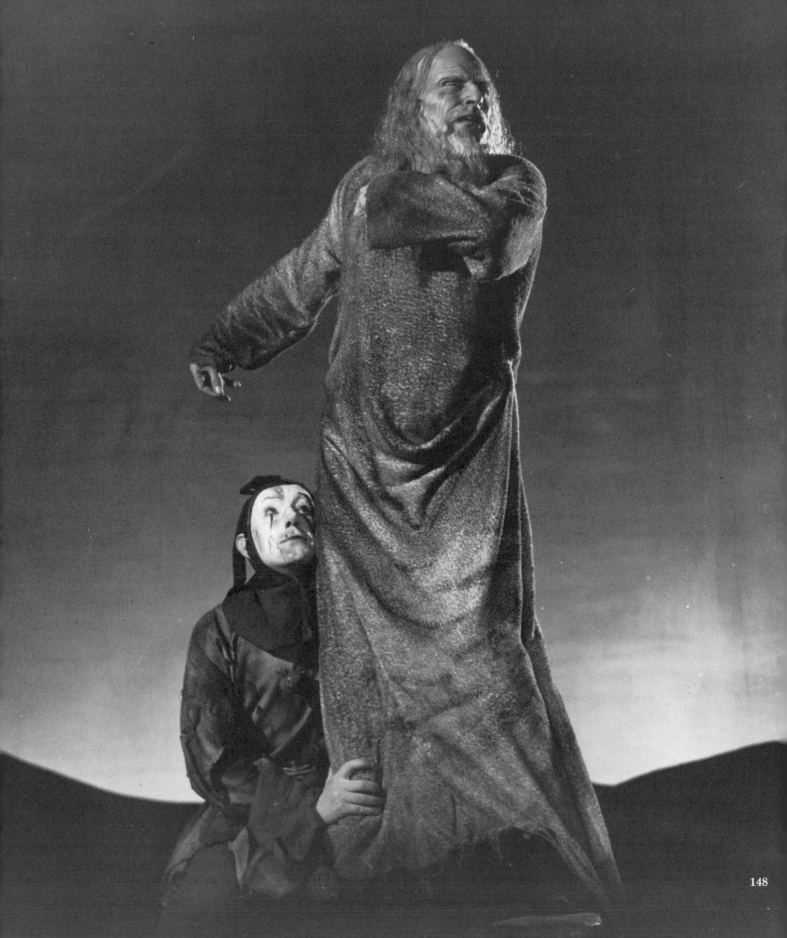

LEAR:

Blow winds, and crack your cheeks; rage, blow
You cataracts, and hurricanoes spout,
Till you have drench'd our steeples, drown'd the cocks.
You sulphurous and thought-executing fires,
Vaunt-couriers of oak-cleaving thunderbolts,
Singe my white head. And thou all-shaking thunder,
Strike flat the thick rotundity o' th' world.
Crack Nature's moulds, all germens spill at once
That makes ingrateful man.

FOOL:

O nuncle, Court holy-water in a dry house, is better than
this rain-water out o'door. Good nuncle, in, ask thy
daughter's blessing; here's a night pities neither wise
men, nor fools.

LEAR:

Rumble thy bellyful: spit fire, spout rain:
Nor rain, wind, thunder, fire are my daughters;
I tax not you, you elements with unkindness.
I never gave you Kingdom, call'd you children;
You owe me no subscription. Then let fall
Your horrible pleasure. Here I stand your slave,
A poor, infirm, weak, and despis'd old man:
But yet I call you servile ministers,
That will with two pernicious daughters join
Your high-engender'd battles, 'gainst a head
So old, and white as this. O, ho! 'tis foul

ACT III SCENE II

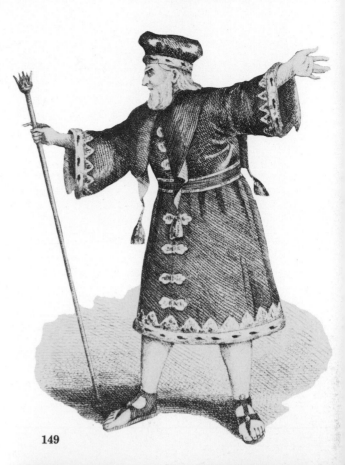

149

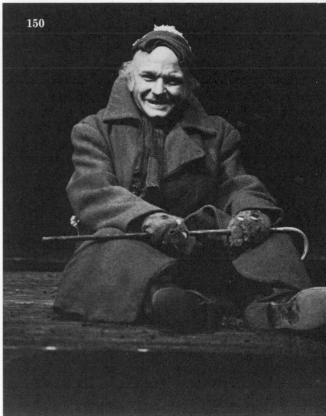

150

148
Lear: Laurence Olivier
Fool: Alec Guinness
New 1946 (Old Vic Production)
Director: Laurence Olivier

149
Lear: Edmund Kean
Drury Lane 1820

150
Fool: Michael Williams
RSC Aldwych 1977
Director: Trevor Nunn

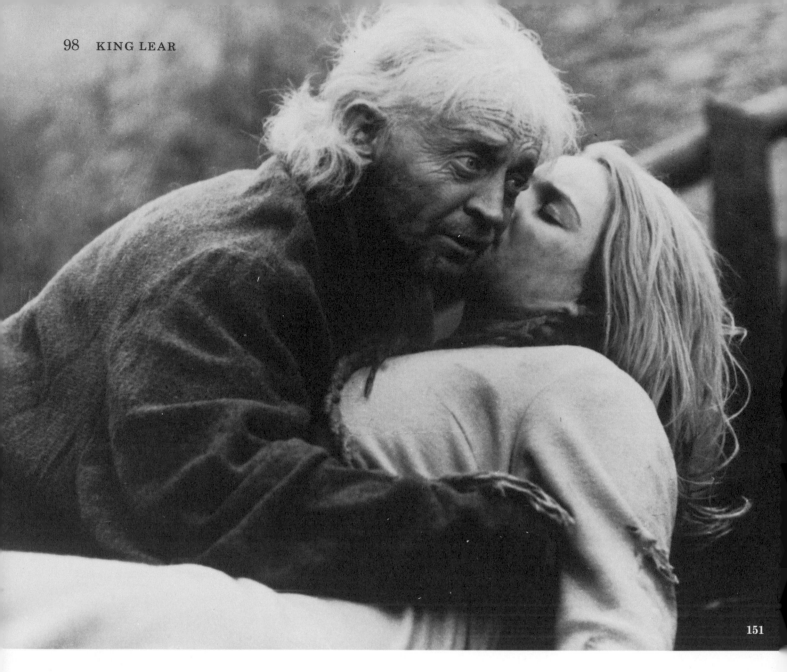

151

LEAR:

No, no, no, no: come let's away to prison,
We two alone will sing like birds i' th' cage:
When thou dost ask me blessing, I'll kneel down
And ask of thee forgiveness: so we'll live,
And pray, and sing, and tell old tales, and laugh
At gilded butterflies: and hear (poor rogues)
Talk of Court news, and we'll talk with them too,
Who loses, and who wins; who's in, who's out;
And take upon's the mystery of things,
As if we were God's spies: and we'll wear out
In a wall'd prison, packs and sects of great ones,
That ebb and flow by th' moon.

ACT IV SCENE III

151
Lear: Yuri Jarvet
Russian Film 1970
Director: Grigori Kozintsev

152
Lear: William Charles Macready
Cordelia: Helena Faucit
Covent Garden 1838

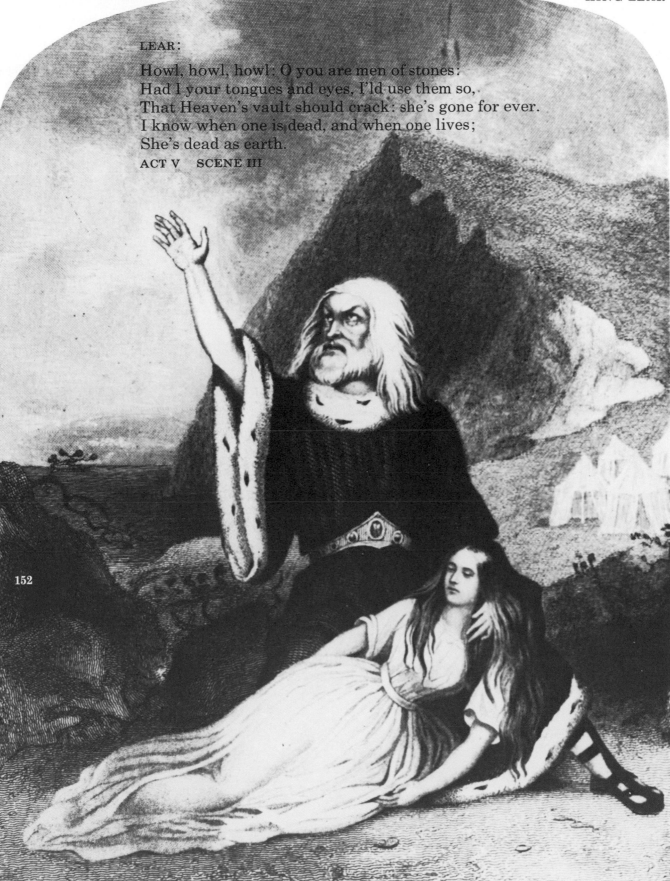

LEAR:

Howl, howl, howl: O you are men of stones:
Had I your tongues and eyes, I'ld use them so,
That Heaven's vault should crack: she's gone for ever.
I know when one is dead, and when one lives;
She's dead as earth.
ACT V SCENE III

152

Macbeth

MACBETH:

Tomorrow, and tomorrow, and tomorrow,
Creeps in this petty pace from day to day
To the last syllable of recorded time;
And all our yesterdays have lighted fools
The way to dusty death. Out, out, brief candle!
Life's but a walking shadow, a poor player
That struts and frets his hour upon the stage
And then is heard no more. It is a tale
Told by an idiot, full of sound and fury,
Signifying nothing.

ACT V SCENE V

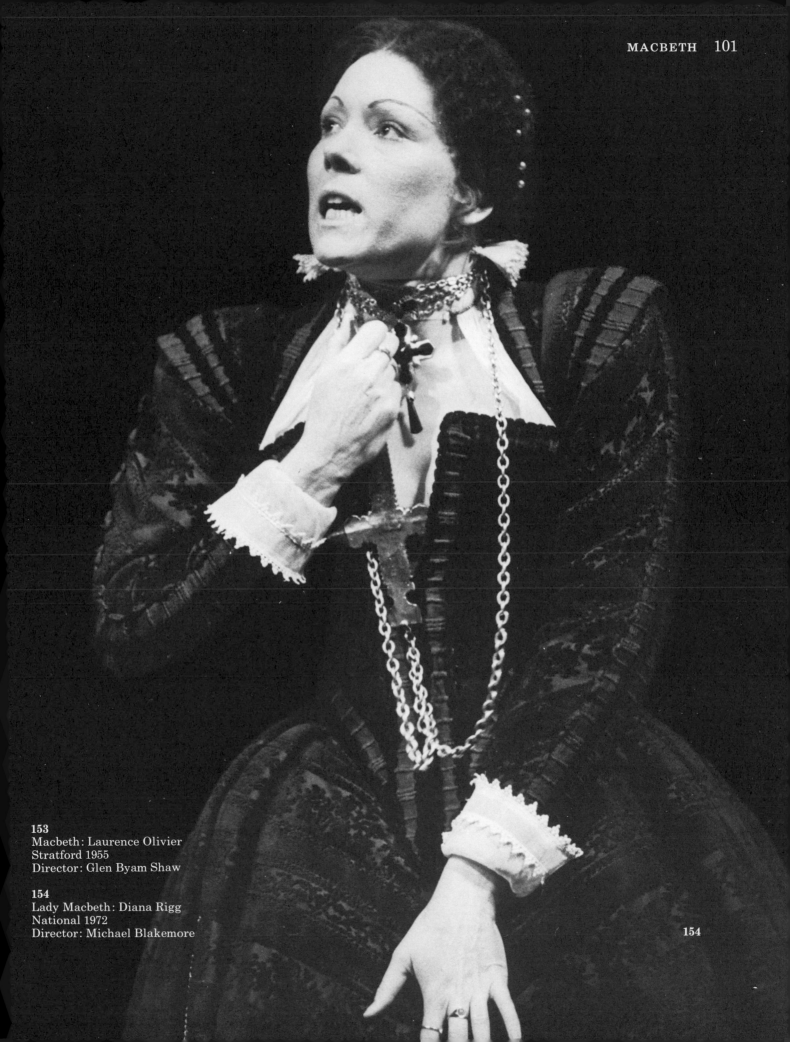

153
Macbeth: Laurence Olivier
Stratford 1955
Director: Glen Byam Shaw

154
Lady Macbeth: Diana Rigg
National 1972
Director: Michael Blakemore

154

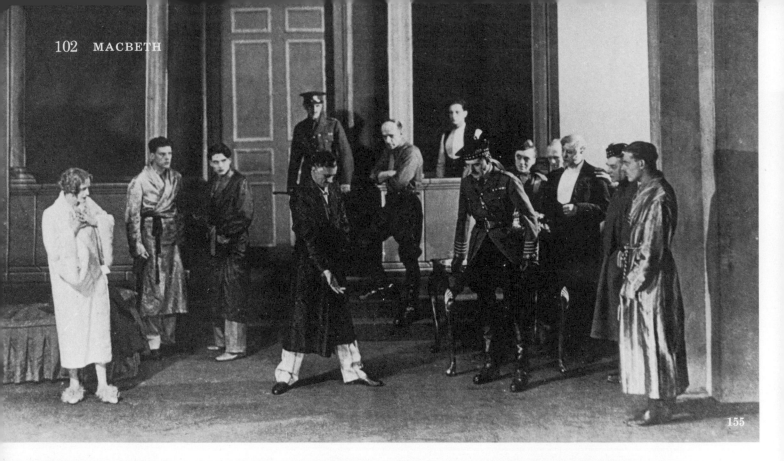

155

156

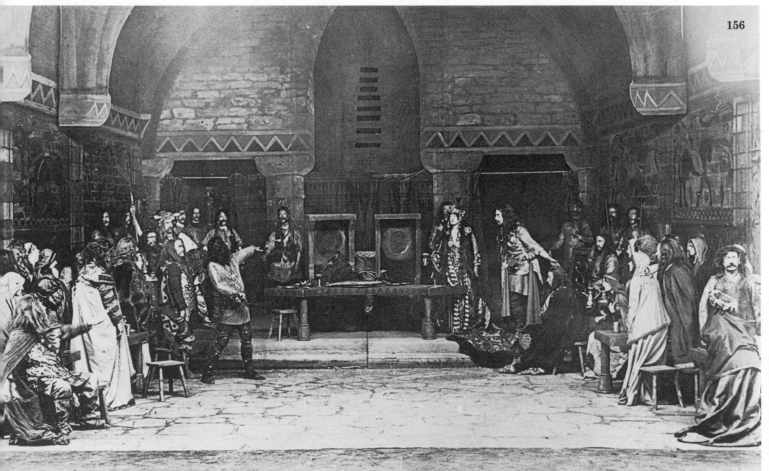

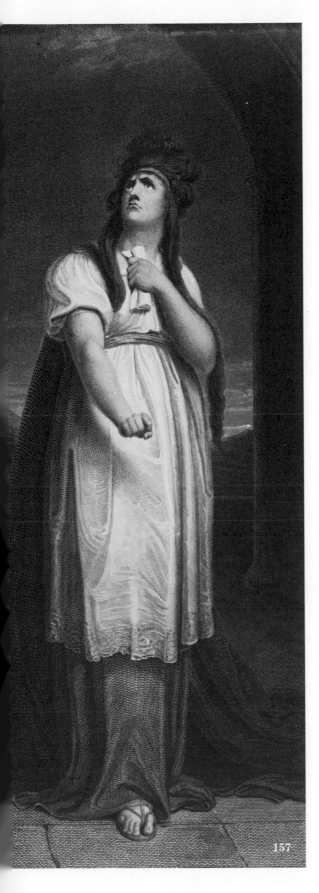

LADY MACBETH:

 The raven himself is hoarse
That croaks the fatal entrance of Duncan
Under my battlements. Come, you spirits
That tend on mortal thoughts, unsex me here
And fill me from the crown to the toe top-full
Of direst cruelty. Make thick my blood;
Stop up the access and passage to remorse,
That no compunctious visitings of nature
Shake my fell purpose, nor keep peace between
The effect and it. Come to my woman's breasts
And take my milk for gall, you murdering ministers,
Wherever, in your sightless substances,
You wait on nature's mischief. Come, thick night,
And pall thee in the dunnest smoke of hell,
That my keen knife see not the wound it makes,
Nor heaven peep through the blanket of the dark
To cry, 'Hold, hold!'

ACT I SCENE V

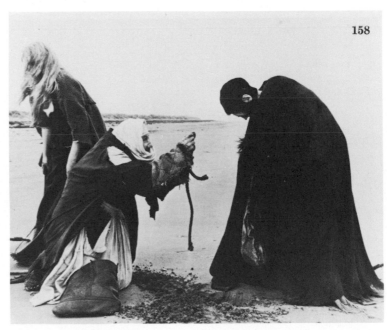

158

155
Macbeth: Eric Maturin
Lady Macbeth: Mary Merrall
Court 1928
Director: Barry Jackson

156
Macbeth: Herbert Beerbohm Tree
Lady Macbeth: Violet Vanbrugh
His Majesty's 1911
Director: Herbert Beerbohm Tree

157
Lady Macbeth: Sarah Siddons
(1755–1831)

158
Witches: Noel Rimmington
 Elsie Taylor
 Maisie MacFarquhar
Playboy/Caliban Film 1971
Director: Roman Polanski

157

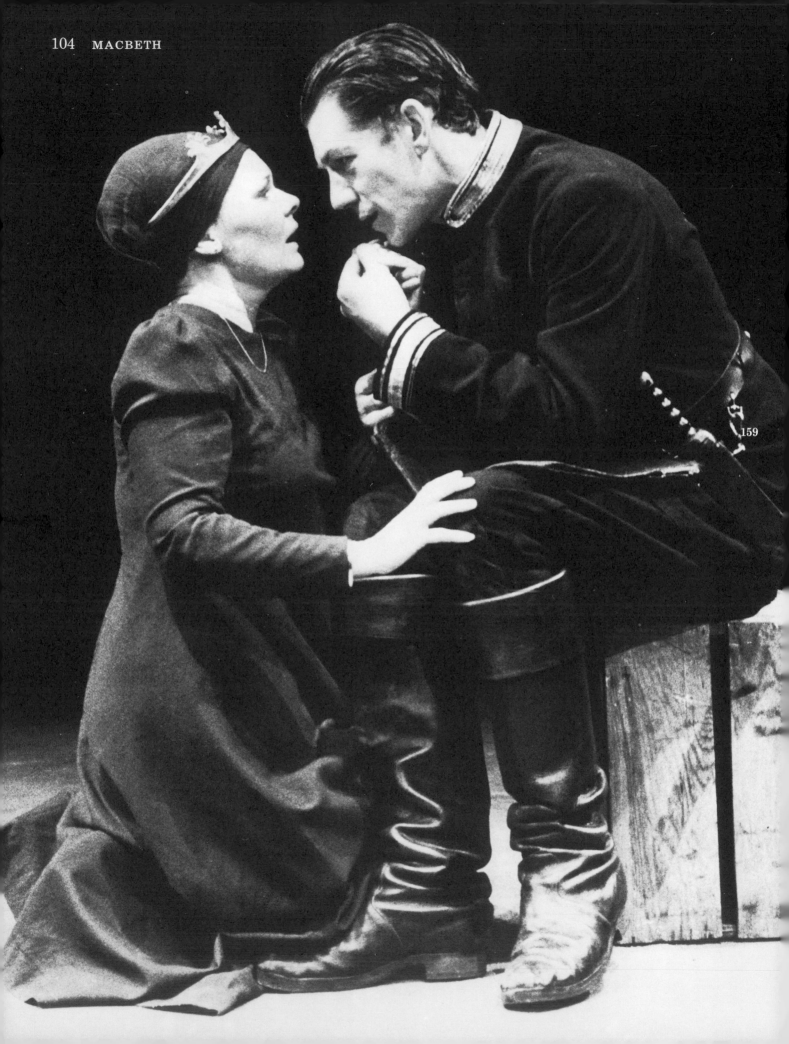

159

MACBETH:

It it were done when 'tis done, then 'twere well
It were done quickly. If the assassination
Could trammel up the consequence, and catch
With his surcease success – that but this blow
Might be the be-all and the end-all! – here,
But here, upon this bank and shoal of time,
We'd jump the life to come. But in these cases
We still have judgement here – that we but teach
Bloody instructions, which, being taught, return
To plague the inventor. This even-handed justice
Commends the ingredience of our poisoned chalice
To our own lips. He's here in double trust:
First, as I am his kinsman and his subject,
Strong both against the deed; then, as his host,
Who should against his murderer shut the door,
Not bear the knife myself. Besides, this Duncan
Hath borne his faculties so meek, hath been
So clear in his great office, that his virtues
Will plead like angels, trumpet-tongued against
The deep damnation of his taking-off;
And Pity, like a naked new-born babe
Striding the blast, or heaven's cherubin, horsed
Upon the sightless curriers of the air,
Shall blow the horrid deed in every eye,
That tears shall drown the wind. I have no spur
To prick the sides of my intent but only
Vaulting ambition which o'erleaps itself
And falls on the other.

ACT I SCENE VII

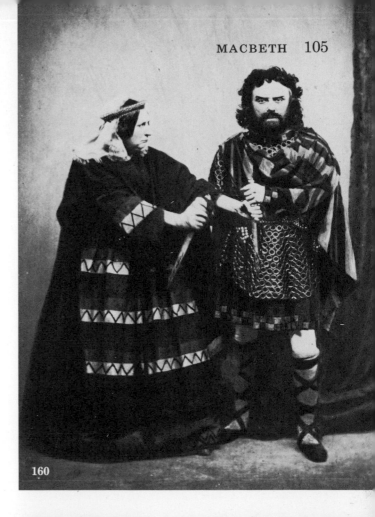

160

161

160
Macbeth: Charles Kean
Lady Macbeth: Mrs. Charles Kean
Princess 1858
Director: Charles Kean

159
Macbeth: Ian McKellen
Lady Macbeth: Judi Dench
RSC Warehouse 1977
Director: Trevor Nunn

161
Macbeth: Peter O'Toole
Old Vic 1980
Director: Bryan Forbes

MACBETH:

Is this a dagger which I see before me,
The handle toward my hand? Come, let me clutch thee –
I have thee not and yet I see thee still!
Art thou not, fatal vision, sensible
To feeling as to sight? Or art thou but
A dagger of the mind, a false creation,
Proceeding from the heat-oppressèd brain?
I see thee yet, in form as palpable
As this which now I draw.
Thou marshall'st me the way that I was going,
And such an instrument I was to use. –
Mine eyes are made the fools o'the other senses,
Or else worth all the rest. – I see thee still;
And, on thy blade and dudgeon, gouts of blood,
Which was not so before. There's no such thing.
It is the bloody business which informs
Thus to mine eyes. Now o'er the one half-world
Nature seems dead, and wicked dreams abuse
The curtained sleep. Witchcraft celebrates
Pale Hecat's offerings; and withered murder,
Alarumed by his sentinel the wolf,
Whose howl's his watch, thus with his stealthy pace,
With Tarquin's ravishing strides, towards his design
Moves like a ghost. Thou sure and firm-set earth,
Hear not my steps, which way they walk, for fear
Thy very stones prate of my whereabout
And take the present horror from the time
Which now suits with it. – Whiles I threat, he lives:
Words to the heat of deeds too cold breath gives.
 A bell rings
I go, and it is done; the bell invites me.
Hear it not, Duncan, for it is a knell
That summons thee to heaven or to hell.

ACT II SCENE I

162
Macbeth: David Garrick
Lady Macbeth: Hannah Pritchard
Drury Lane 1768

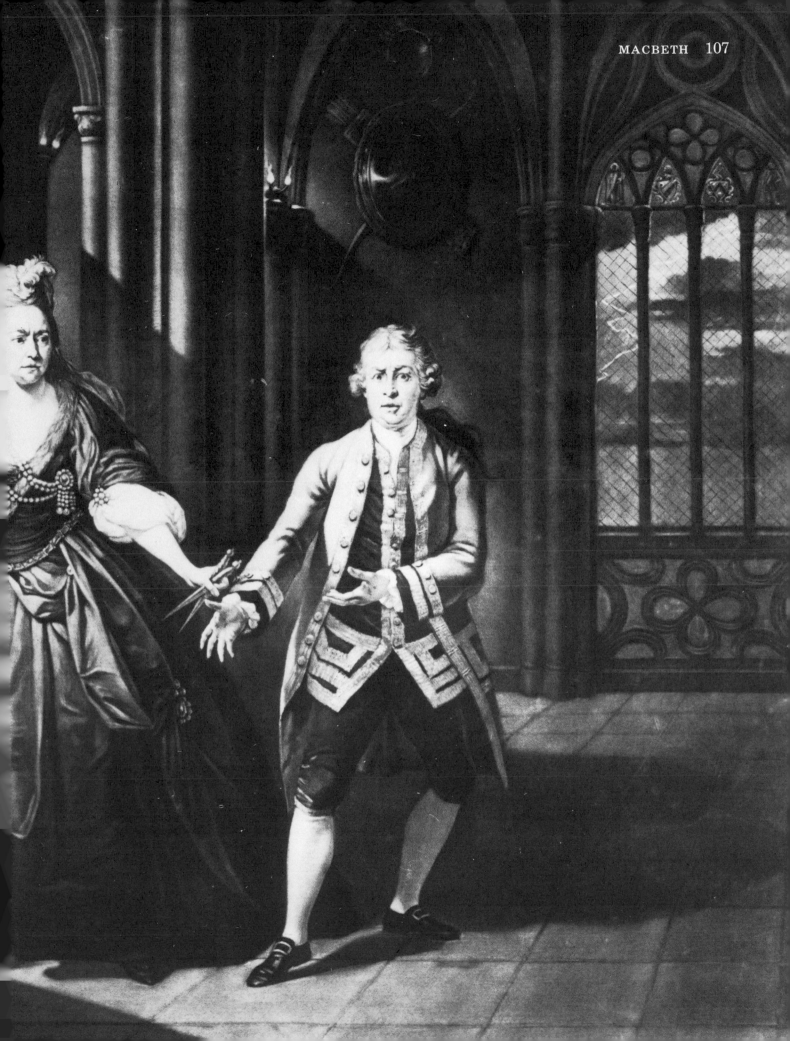

Antony and Cleopatra

Take but good note, and you shall see in him
The triple pillar of the world transform'd
Into a strumpet's fool. Behold and see.

163
Antony: Richard Johnson
Cleopatra: Janet Suzman
RSC Stratford 1972
Director: Trevor Nunn

ENOBARBUS:

Age cannot wither her, nor custom stale
Her infinite variety: other women cloy
The appetites they feed, but she makes hungry,
Where most she satisfies. For vilest things
Become themselves in her, that the holy Priests
Bless her, when she is riggish.

ACT II SCENE II

164
Cleopatra: Isabella Glyn
Sadler's Wells 1849

ENOBARBUS:

The barge she sat in, like a burnish'd Throne
Burnt on the water: the poop was beaten gold,
Purple the sails: and so perfumed that
The winds were love-sick.
With them the oars were silver,
Which to the tune of flutes kept stroke, and made
The water which they beat, to follow faster;
As amorous of their strokes. For her own person,
It beggar'd all description, she did lie
In her pavilion, cloth of gold, of tissue,
O'er-picturing that Venus, where we see
The fancy out-work Nature. On each side her,
Stood pretty dimpled boys, like smiling Cupids,
With divers colour'd fans whose wind did seem,
To glow the delicate cheeks which they did cool,
And what they undid did.

ACT II SCENE II

165
Antony: Godfrey Tearle
Cleopatra: Edith Evans
Piccadilly 1946
Director: Glen Byam Shaw

165

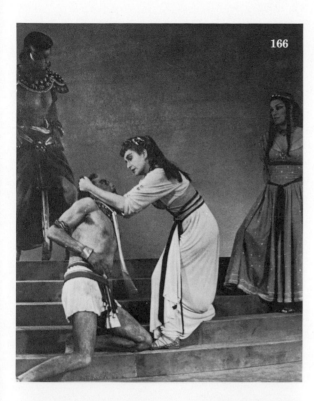

166

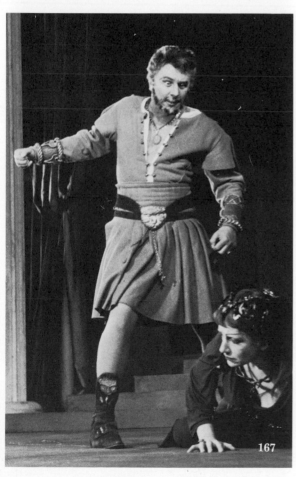

167

166
Alexas: Alan Townsend
Messenger: Powys Thomas
Cleopatra: Peggy Ashcroft
Charmian: Jean Wilson

167
Antony: Michael Redgrave
Cleopatra: Peggy Ashcroft

Stratford 1953
Director: Glen Byam Shaw

ANTONY:
Oh whither has thou led me Egypt, see
How I convey my shame, out of thine eyes,
By looking back what I have left behind
Stroy'd in dishonour.

CLEOPATRA:
 Oh my Lord, my Lord,
Forgive my fearful sails, I little thought
You would have followed.

ANTONY:
Egypt, thou knew'st too well,
My heart was to thy rudder tied by th' strings,
And thou should'st stow me after. O'er my spirit
The full supremacy thou knew'st, and that
Thy beck, might from the bidding of the Gods
Command me.

CLEOPATRA:
 Oh my pardon.

ANTONY:
 Now I must
To the young man send humble treaties, dodge
And palter in the shifts of lowness, who
With half the bulk o' th' world play'd as I pleas'd,
Making and marring fortunes. You did know
How much you were my conqueror, and that
My sword, made weak by my affection, would
Obey it on all cause.

CLEOPATRA:
 Pardon, pardon.

ACT III SCENE XI

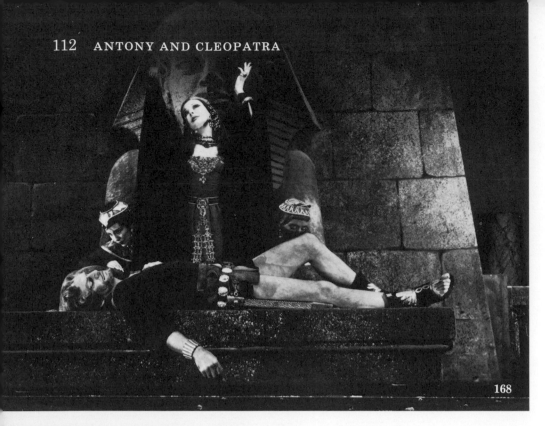

168

168
Antony: Laurence Olivier
Cleopatra: Vivien Leigh
St. James's 1951
Director: Michael Benthall

169 171
Cleopatra: Margaret Leighton
Octavius: Keith Baxter
Chichester 1969
Director: Peter Dews

170
Antony: Herbert Beerbohm Tree
Cleopatra: Constance Collier
Octavius: Basil Gill
His Majesty's 1906
Director: Herbert Beerbohm Tree

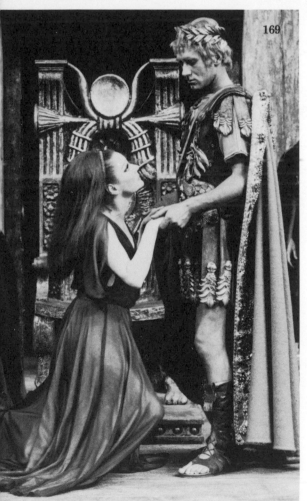

169

CLEOPATRA:

Oh see my women: (*Antony dies*)
The Crown o' th' earth doth melt. My Lord?
Oh wither'd is the garland of the war,
The soldier's pole is fall'n: young boys and girls
Are level now with men: the odds is gone,
And there is nothing left remarkable
Beneath the visiting Moon.
ACT IV SCENE XIII

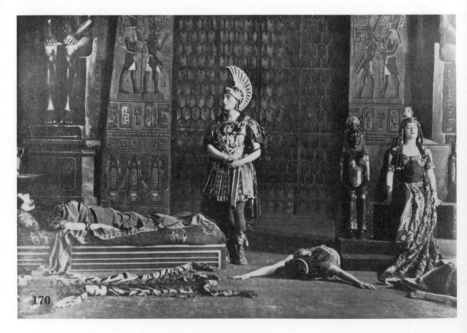

170

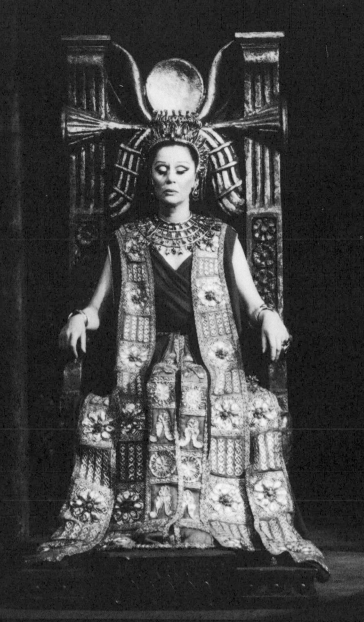

171

CLEOPATRA:

Give me my Robe, put on my Crown, I have
Immortal longings in me. Now no more
The juice of Egypt's grape shall moist this lip.
Yare, yare, good Iras; quick: methinks I hear
Antony call, I see him rouse himself
To praise my noble act. I hear him mock
The luck of Caesar, which the Gods give men
To excuse their after wrath. Husband, I come:
Now to that name, my courage prove my title.
I am fire, and air; my other elements
I give to baser life.
ACT V SCENE II

Coriolanus

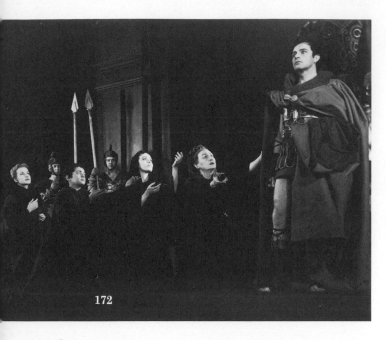

172

CORIOLANUS:

(*holds her by the hand silent*) O, Mother, Mother!
What have you done? Behold, the Heavens do ope,
The Gods look down, and this unnatural scene
They laugh at. Oh my Mother, Mother: Oh!
You have won a happy victory to Rome.
But for your son, believe it: Oh believe it,
Most dangerously you have with him prevail'd,
If not most mortal to him.
ACT V SCENE III

172
Virgilia: Claire Bloom
Volumnia: Fay Compton
Coriolanus: Richard Burton
Old Vic 1954
Director: Michael Benthall

173
Volumnia: Margaret Tyzack
Coriolanus: Nicol Williamson
RSC Aldwych 1973
Director: Trevor Nunn

173

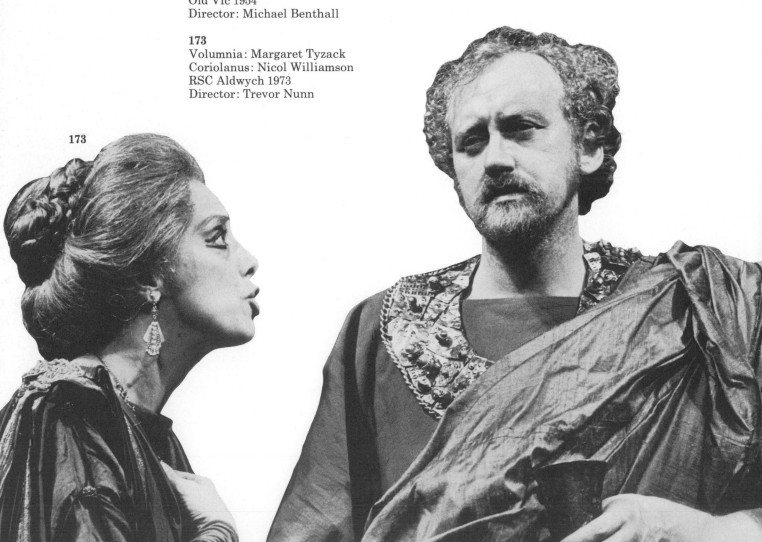

Pericles

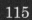

174
Pericles: Paul Scofield
Stratford 1947
Director: Nugent Monck

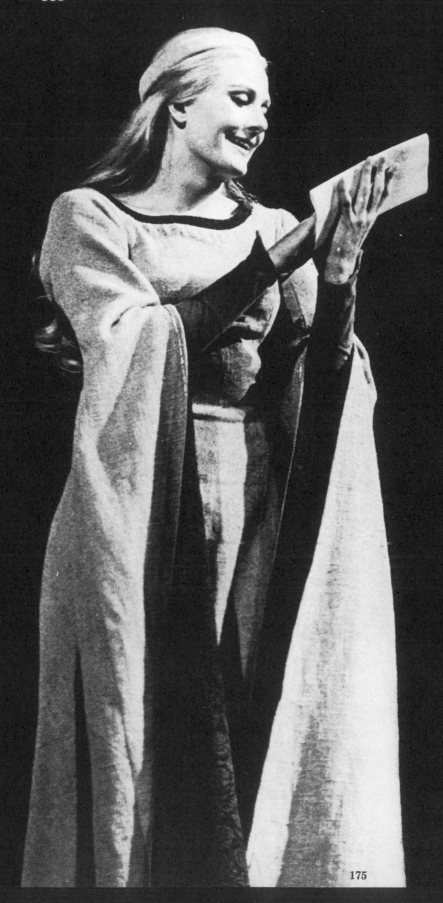

Cymbeline

Song

Fear no more the heat o' the sun
 Nor the furious winter's rages;
Thou thy worldly task hast done,
 Home art gone and ta'en thy wages:
Golden lads and girls all must,
As chimney-sweepers, come to dust.

Fear no more the frown o' the great,
 Thou art past the tyrant's stroke;
Care no more to clothe and eat;
 To thee the reed is as the oak:
The sceptre, learning, physic, must
All follow this, and come to dust.

Fear no more the lightning-flash
 Nor the all-dreaded thunder-stone;
Fear not slander, censure rash;
 Thou hast finished joy and moan:
All lovers young, all lovers must
Consign to thee, and come to dust.

ACT IV SCENE II

175
Imogen: Vanessa Redgrave
RSC Stratford 1962
Director: William Gaskill

175

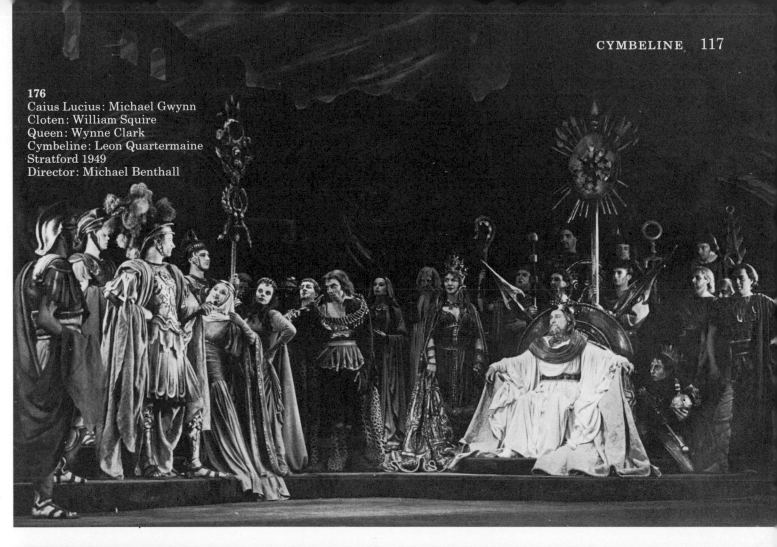

176
Caius Lucius: Michael Gwynn
Cloten: William Squire
Queen: Wynne Clark
Cymbeline: Leon Quartermaine
Stratford 1949
Director: Michael Benthall

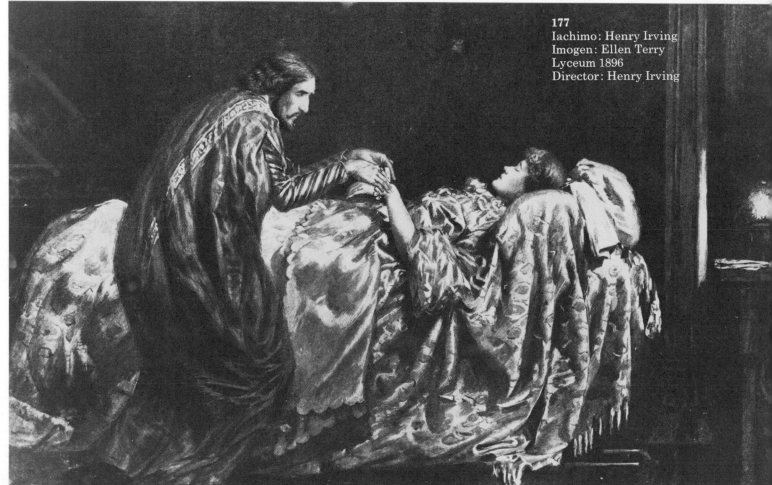

177
Iachimo: Henry Irving
Imogen: Ellen Terry
Lyceum 1896
Director: Henry Irving

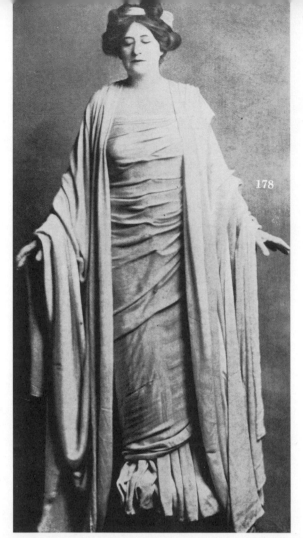

178

The Winter's Tale

PAULINA:

 Music, awake her: strike.
'Tis time; descend; be stone no more; approach;
Strike all that look upon with marvel; come;
I'll fill your grave up. Stir; nay, come away;
Bequeath to death your numbness, for from him
Dear life redeems you. You perceive she stirs.
 [*Hermione comes down.*]
Start not; her actions shall be holy as
You hear my spell is lawful. Do not shun her
Until you see her die again, for then
You kill her double. Nay, present your hand.
When she was young, you wooed her; now, in age,
Is she become the suitor?

LEONTES:

 Oh, she's warm!
If this be magic, let it be an art
Lawful as eating.

ACT V SCENE VIII

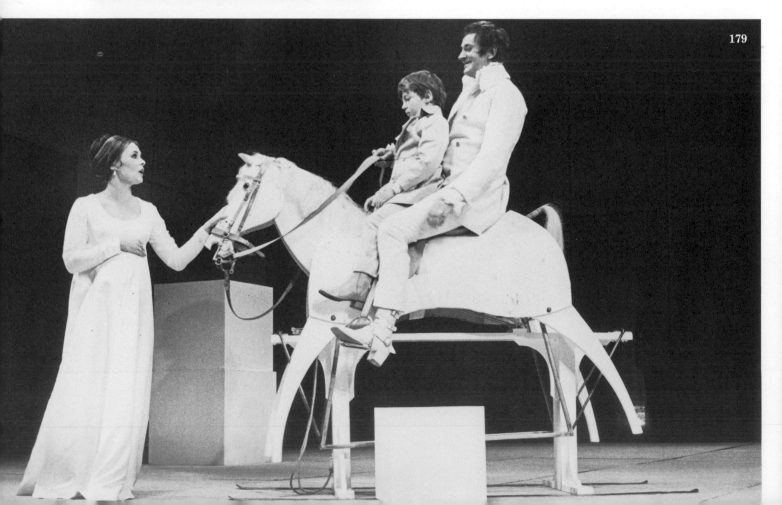

179

178
Hermione: Ellen Terry
His Majesty's 1906
Director: Herbert Beerbohm Tree

179
Hermione: Judi Dench
Mamillius: Jeremy Richardson
Leontes: Barrie Ingham
RSC Stratford 1969
Director: Trevor Nunn

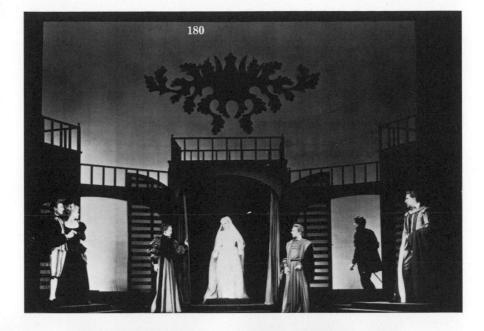

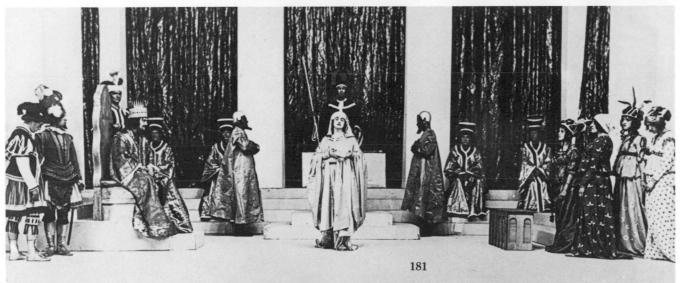

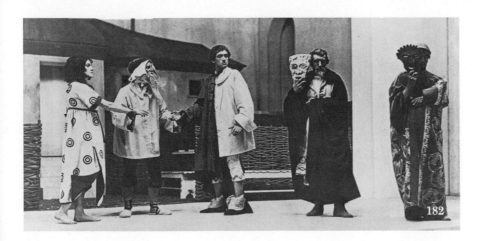

180
Paulina: Flora Robson
Hermione: Diana Wynyard
Leontes: John Gielgud
Phoenix 1951 (Stratford Production)
Director: Peter Brook

181 182
Leontes: Henry Ainley
Hermione: Lillah McCarthy
Perdita: Cathleen Nesbitt
Old Shepherd: H. O. Nicholson
Florizel: Dennis Neilson-Terry
Savoy 1912
Director: Harley Granville-Barker

The Tempest

PROSPERO:

Ye elves of hills, brooks, standing lakes and groves,
And ye, that on the sands with printless foot
Do chase the ebbing Neptune, and do fly him
When he comes back: you demi-puppets, that
By moonshine do the green sour ringlets make,
Whereof the ewe not bites: and you, whose pastime
Is to make midnight mushrumps, that rejoice
To hear the solemn curfew, by whose aid
(Weak masters though ye be) I have bedimm'd
The noontide Sun, call'd forth the mutinous winds,
And 'twixt the green sea, and the azur'd vault
Set roaring war: to the dread rattling thunder
Have I given fire, and rifted Jove's stout oak
With his own bolt: the strong-bas'd promontory
Have I made shake, and by the spurs pluck'd up
The pine, and cedar. Graves at my command
Have wak'd their sleepers, op'd, and let 'em forth
By my so potent Art. But this rough magic
I here abjure: and when I have requir'd
Some heavenly music (which even now I do)
To work mine end upon their senses, that
This airy charm is for, I'll break my staff,
Bury it certain fathoms in the earth,
And deeper than did ever plummet sound
I'll drown my book.

ACT V SCENE I

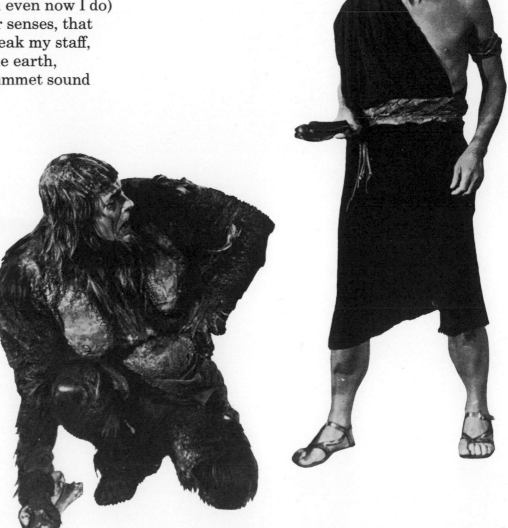

183
Prospero: Michael Redgrave
Ariel: Alan Badel
Stratford 1951
Director: Michael Benthall

184
Caliban: Alec Clunes
Prospero: John Gielgud
Drury Lane 1958
(Stratford Production)
Director: Peter Brook

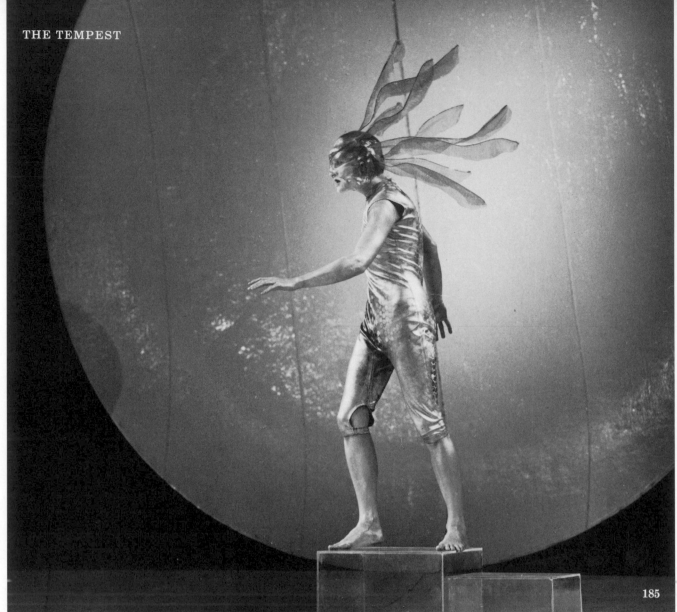

185

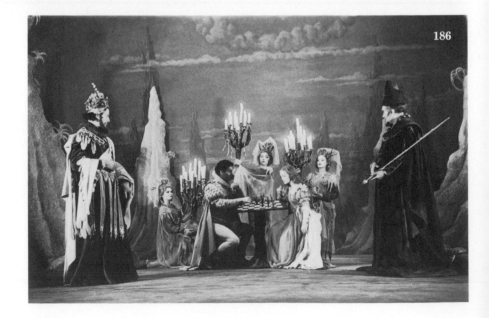

186

185
Ariel: John Kane
Chichester 1968
Director: David Jones

186
Miranda: Zena Walker
Ferdinand: Alexander Davion
Stratford 1952
Director: Michael Benthall

187
Prospero: Robert Eddison
Open Air Regents Park 1955
Director: David William

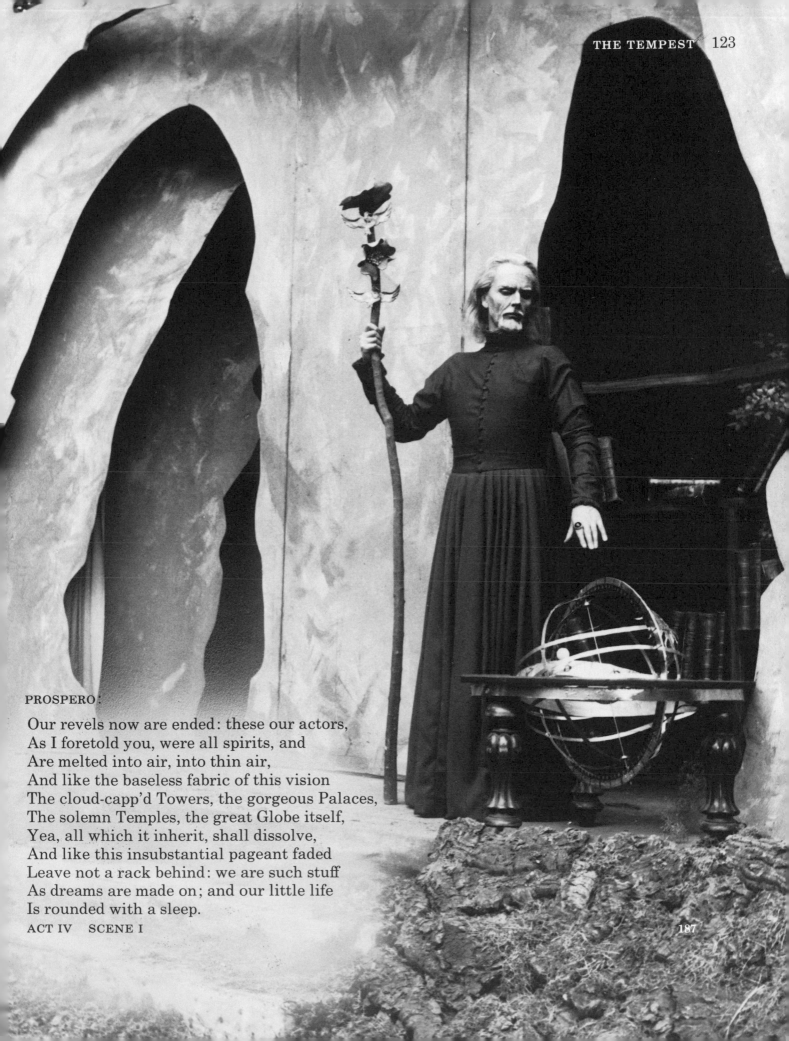

PROSPERO:

Our revels now are ended: these our actors,
As I foretold you, were all spirits, and
Are melted into air, into thin air,
And like the baseless fabric of this vision
The cloud-capp'd Towers, the gorgeous Palaces,
The solemn Temples, the great Globe itself,
Yea, all which it inherit, shall dissolve,
And like this insubstantial pageant faded
Leave not a rack behind: we are such stuff
As dreams are made on; and our little life
Is rounded with a sleep.

ACT IV SCENE I 187

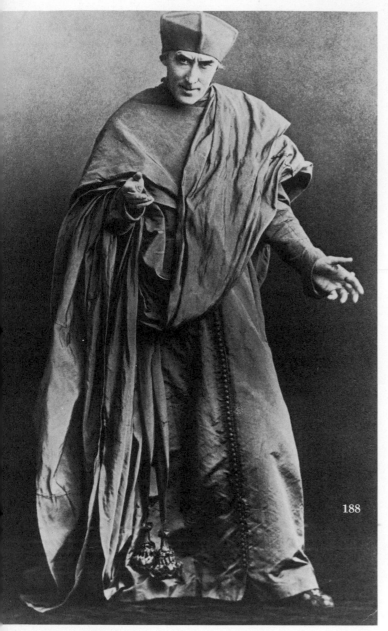

188

Henry VIII

WOLSEY:

So farewell, to the little good you bear me.
Farewell? A long farewell to all my Greatness.
This is the state of Man; today he puts forth
The tender leaves of hopes, tomorrow blossoms,
And bears his blushing honours thick upon him:
The third day, comes a frost; a killing frost,
And when he thinks, good easy man, full surely
His greatness is a-ripening, nips his root,
And then he falls as I do. I have ventur'd
Like little wanton boys that swim on bladders:
This many summers in a sea of Glory,
But far beyond my depth: my high-blown Pride
At length broke under me, and now has left me
Weary, and old with service, to the mercy
Of a rude stream, that must for ever hide me.
Vain pomp, and glory of this World, I hate ye,
I feel my heart new open'd. Oh how wretched
Is that poor man, that hangs on Princes' favours?
There is betwixt that smile we would aspire to,
That sweet aspect of Princes, and their ruin,
More pangs, and fears than wars, or women have;
And when he falls, he falls like Lucifer,
Never to hope again.
ACT III SCENE II

188
Wolsey: Henry Irving
Lyceum 1892
Director: Henry Irving

189
Wolsey: Alexander Knox
Katharine: Gwen Ffrangcon-Davies
Henry VIII: Paul Rogers
Old Vic 1953
Director: Tyrone Guthrie

190
Henry VIII: Donald Sinden
Katharine: Peggy Ashcroft
Wolsey: Brewster Mason
RSC Aldwych 1970
Director: Trevor Nunn

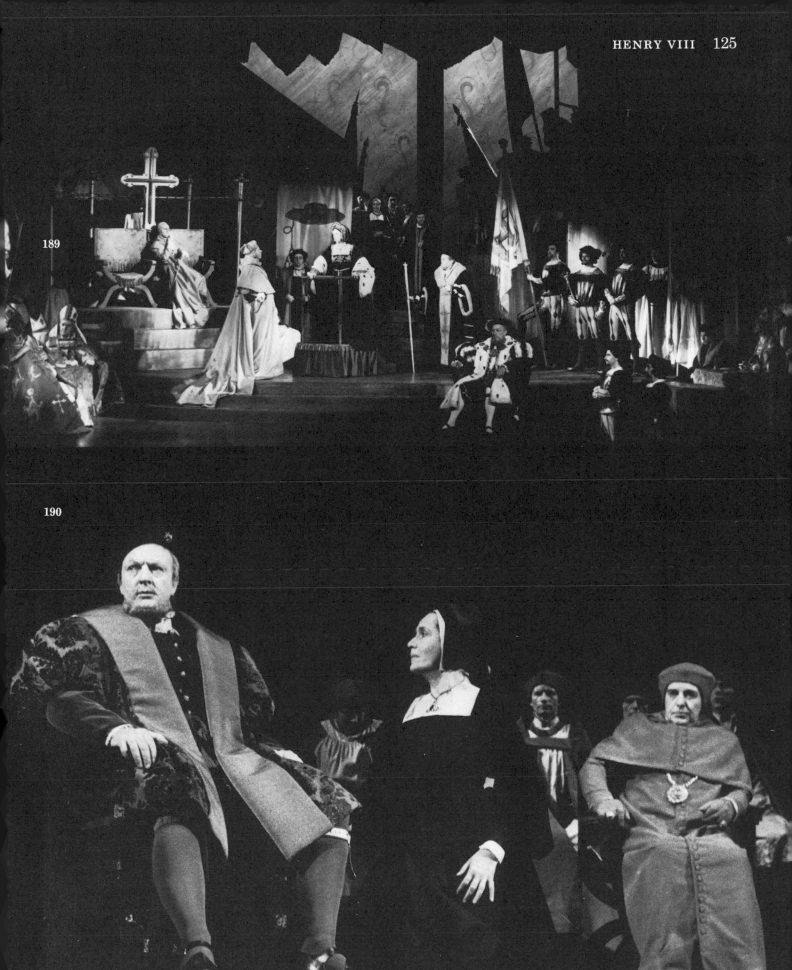

189

190

Index

ILLUSTRATIONS (*All figures refer to caption numbers*)

The author and publisher would like to express their appreciation to the following for their assistance and/or permission to reproduce the illustrations.

THE ROYAL SHAKESPEARE THEATRE COLLECTION, SHAKESPEARE CENTRE LIBRARY: 1, 2, 3, 11, 12, 13, 18, 19, 23, 24, 29, 37, 39, 40, 42, 43, 47, 48, 51, 53, 54, 62, 63, 66, 68, 69, 70, 71, 72, 74, 80, 88, 89, 97, 101, 103, 105, 109, 112, 113, 121, 122, 123, 124, 126, 130, 131, 134, 135, 136, 139, 141, 144, 145, 147, 150, 153, 155, 156, 159, 163, 166, 173, 174, 175, 176, 179, 181, 182, 183, 184, 190.

THE RAYMOND MANDER AND JOE MITCHENSON THEATRE COLLECTION

RADIO TIMES HULTON PICTURE LIBRARY

VICTORIA AND ALBERT MUSEUM, CROWN COPYRIGHT

HARVARD THEATRE COLLECTION (for the Angus McBean photographs: 125, 140, 168, 172, 180)

THE NATIONAL THEATRE

THE PROSPECT THEATRE COMPANY

THE NATIONAL PORTRAIT GALLERY

THE NATIONAL FILM ARCHIVES STILL LIBRARY

COLUMBIA/WARNER LONDON FILMS
CONTEMPORARY FILMS MGM
EAGLE FILMS PARAMOUNT
GALA FILMS PLAYBOY/CALIBAN
HARRIS FILMS 20th CENTURY FOX
J. ARTHUR RANK UNITED ARTISTS

The author would like to add a personal thank-you to Raymond Mander and Joe Mitchenson; Mary White and The Shakespeare Birthplace Trust; Ruth Kaplan and The RSC Aldwych press office; Molly Sole and The Old Vic; Mrs Houston Rogers; and Mrs John Vickers.

REFERENCE USE

3/84

DIRECTORS

792.95 Tanitch, Robert.
TAN

Copy #1
3/84

A pictorial
companion to
Shakespeare's
plays

DATE		

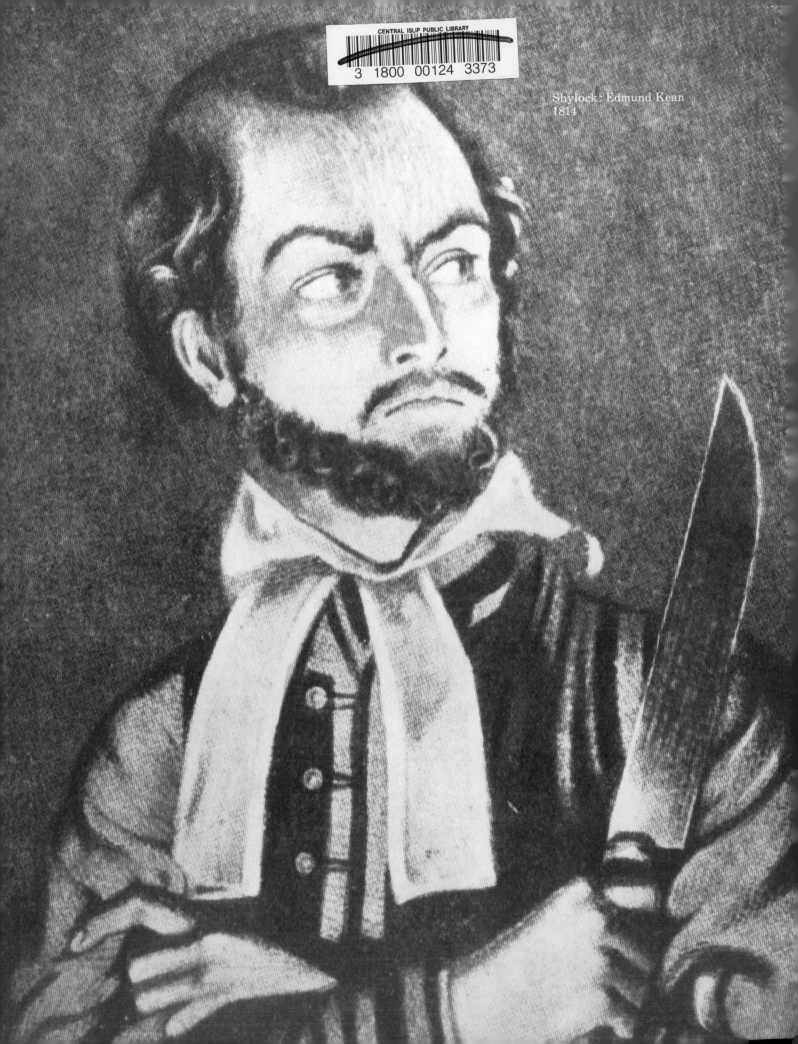

Shylock: Edmund Kean
1814